SECRET ROYAL LEAMINGTON SPA

Graham Sutherland

AMBERLEY

First published 2023

Amberley Publishing
The Hill, Stroud
Gloucestershire, GL5 4EP

www.amberley-books.com

ISBN 978 1 3981 1519 4 (print)
ISBN 978 1 3981 1520 0 (ebook)

British Library Cataloguing in Publication Data.
A catalogue record for this book is available from the
British Library.

Origination by Amberley Publishing.
Printed in Great Britain.

Contents

Introduction

Royal Leamington Spa, hereinafter called Leamington, was once known as Leamington Priors. Then part of Stoneleigh and belonging to the priors of Kenilworth, it was mentioned in the Domesday Book (1086). Despite these earlier origins, the town has only come to prominence in the past 200-plus years. With the Revolutionary and Napoleonic Wars raging between 1792 and 1815, foreign travel was restricted and led to a growth of holiday/medical centres in England. Leamington, taking its name from the River Leam, hereinafter called the Leam, on which it stands, was one such venue. The Regency and Victorian periods were very influential in Leamington's growth, hence names such as Regent Street and the Regent Hotel.

Until the 1940s, when 'taking the waters' had ceased being a major attraction, Leamington remained a haven for retired people, albeit mainly for those who had held senior positions during their careers in the army, Church, navy, and civil service. The growth of local industries, such as Sidney Flavel & Co., led to change. Today's emphasis is on a younger, varied, cultural generation, including the controversial growth of houses of multiple occupancy (HMOs) for students.

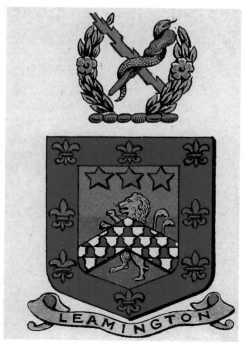

Town crest.

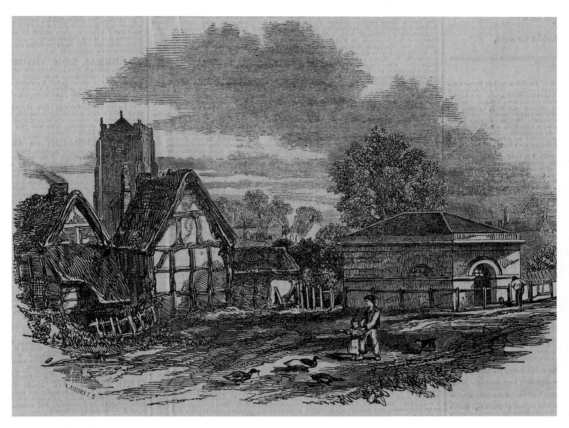

An old well.

After being described in 1881 as one of the 'gloomiest towns in England', more modern facilities were installed to attract visitors, leading to Parade gas lights being replaced by electricity.

In 1830, Princess Victoria stayed in the Regent Hotel and visited the Royal Pump Room. The year after her accession, 1838, she granted permission for the town to be called Royal Leamington Spa. A subsequent attempt in 2001 by the Lord Chancellor to claim the title failed. After the charter arrived, Leamington enjoyed elegant town facilities so popular in years gone by (albeit many houses came from other copied plans and designs). However, it was also felt that there was a need to keep the classes apart socially.

Leamington has not stood still but has changed over the years. Today there is a massive housebuilding programme underway, which has already changed the face of the town forever despite not being finished yet.

Much has been written about Leamington, but this book explores some of the lesser-known snippets of life here over the ages.

Leamington postcard.

Souvenir.

1. Taking the Waters

Did people visit Leamington because they had to, or were they here for a good time? Undertaking a course of 'taking the waters' was not for the fainthearted! The recommended course lasted between a month and six weeks, between May and October, and was not as rigorous as Malvern. Drinking and bathing in the water only occupied a small part of the day, and there were other activities for patients to enjoy. Nevertheless, all these activities required money and Leamington had more than one spa.

The local media advised of new arrivals and Leamington soon became a honeypot for widows and young ladies seeking husbands, and men seeking wives. Should a lady find herself pregnant after one of these visits, they usually blamed their condition on 'something in the water'.

Masters of Ceremonies had the task of creating demanding social programmes, including advising and enforcing dress codes. The Jephson Gardens provided opportunities for the gentler exercises. When night fell, balls, suppers, soirées, playing cards and other more genteel pursuits followed.

Aylesford Well

The first mention of a well in Leamington was in 1123. The well, near to All Saints' Church, was briefly mentioned in 1586 by the historian and topographer William Camden. It was called the Camden Well in his honour, but later became known as the Aylesford Well after its owner. Lord Aylesford was adamant these waters were to be made available to the poor free of charge. At the same time, however, he was not enthusiastic about developing his source of Leamington's water, and a search began to find another.

Until 1784, the waters were used in a desultory fashion. Then local shoemaker Benjamin Satchwell and his friend William Abbots found a saline spring and established other baths. Local doctor William Lambe, called the 'Father of Veganism', supported their medicinal claims, and a growing number of visitors appeared. In 1803, Lord Aylesford erected a shelter over his well, which he enlarged ten years later. He charged a small admission fee but allowed free access to a nearby pump. Water had previously been available in an oval tub that belonged to a local pig butcher. Messrs Satchwell and Abbotts created a charity providing bathing facilities for poor people.

In 1900, the police were instructed to 'move loungers on'. The author remembers seeing unsavoury tin mugs chained to the well's tiled walls for use when drinking here. People took water home for bathing purposes. To say it was unhygienic was an understatement. It was demolished in the 1960s, being replaced in 2008 by a controversial piece of modern sculpture that is supposed to represent the spa waters. As its name suggests, this was the main ingredient of Spa Water Toffee.

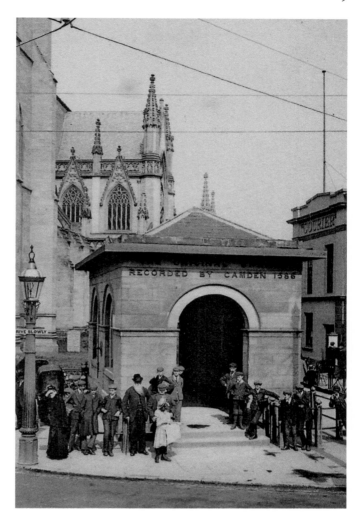

Water source.

Ironically, while the spa water (a natural spring of saline water of muriated sulphate) was beneficial for one's health, the poor quality of domestic water undoubtedly contributed to the cholera outbreak of 1849. Drinking water came from the Leam, which sewage flowed into. Suggestions to build freshwater wells were opposed on erroneous grounds that such activities would affect the spa waters. This attitude prevailed until 1870.

Leamington's spa water was a laxative, so overindulgence was definitely not recommended. The appropriate measure was half a pint before breakfast and a similar amount in the evening. It was followed by gentle exercise to avoid drowsiness. It tasted unpleasantly saltish when cold and much worse when heated. Parents were advised to administer it to their children just before they ate, when they were unable to run off, and hoped they would soon come to like it! These waters are similar to those found in Germany. Ladies with more delicate constitutions had water delivered to them.

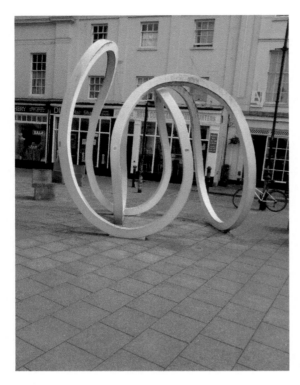

Modern sculpture.

Royal Pump Room and Baths

In 1813, a group of local businessmen met, and the idea of the Royal Pump Room was born. The building opened in 1814 with originally twenty baths (seventeen hot and three cold) and was an instant success. It is now known as the Royal Pump Room and Baths. It was an evolving project and changes followed when the railway appeared in 1844. Turkish Baths and Swimming Baths came later. Advertising emphasised: 'There are the usual contrivances for invalids and cripples.'

It was not always plain sailing, with various problems to overcome. Ironically, the water treatments were moved to the nearby Warneford Hospital in 1990 but returned three years later following the Warneford's demolition.

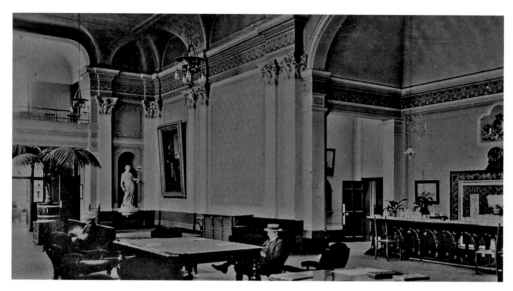

Pump room.

Construction, improvements and upkeep came with problems. One occurred when a 2-hp steam engine, made by Boulton and Watt's Soho Foundry in Birmingham, was being installed. The celebrated engineer William Murdoch oversaw the work until a part fell onto his leg. He returned to Birmingham by canal. Another problem arose in late 1840 when a flue had to be dismantled to rescue a trapped chimney sweep. This was the same year when chimney sweeps under the age of twenty-one were prohibited from climbing up flues. The records do not make it clear whether this incident happened before or after the legislation was introduced. In any case it was widely ignored, and in 1881 the police were urged to report master sweeps who still employed small children for this work.

It was also claimed that the building was sinking into the Leam, contaminating it. As time progressed, the Pump Room became a popular meeting place for afternoon tea, always accompanied by live music. When the music was stopped, it upset the ladies so much it was broadcast on the television, with live music playing out as the programme ended. Social events still happen here.

A memorable event happened in 1964 to commemorate the Pump Room's 150th year: a Regency Ball, where guests were requested to attend in the appropriate costume. If you did so and went to the Regent Hotel, you were conveyed to the event in an open-top carriage, which all added to the atmosphere. The author and his fiancée took advantage of this transport. On the way, they were overtaken by two running footmen carrying a passenger in a sedan chair and demanding people get out of their way. Just as they passed the carriage, one of the chair's spars broke, depositing all three of them in an untidy heap, much to people's amusement. The food was a superb buffet, and if you knew where to look (albeit with help from the bar staff) you could buy rum at its 1814 price.

Regency Ball, 1964.

Jephson Gardens

These were once 13 acres of woodland and gardens privately owned by the Willes family. Opened to the public in 1832, from 7 to 10 a.m. daily for walking and archery, they were leased out by Edward Willes for a number of years. Dr Henry Jephson, who included Florence Nightingale among his patients, took them over and is remembered by his statue in the Temple Memorial, created by Peter Hollins from Birmingham. Edward Willes was unhappy with this arrangement, especially when in 1873 an inferior obelisk was erected to him. In the late twentieth century, one of the hands on Jephson's statue was damaged and it took a while for it to be repaired. While taking a group of American tourists around the gardens one evening, the author related this story. One of his audience suggested the hand had been damaged by the ghost of Edward Willes!

The lake remains a big attraction today, but when its first fountains were constructed model boats could no longer be sailed there. This resulted in ducks and swans taking over, which soon led to the popular pastime of taking children to feed them. Charles Blondin, the famous tightrope walker, reputedly walked over the lake. Before modern health and safety legislation appeared, the author can remember people skating on the frozen lake until chased off by the park keeper. Today access is not so easy.

These gardens have long been a venue for concerts, with the first bandstand opening in 1852. A second one was sited further back following complaints from Newbold Terrace residents about the noise. What would they have thought about today's modern loud music? In 1907, police constables were instructed to patrol there when concerts were playing, but they 'were not to stand in one place listening to the music'. Admission fees

were doubled on concert days. Entrance was by coin-operated turnstiles, being removed in 1971 with the advent of decimal coinage. Children were not always popular or wanted here; for instance, boys were to be chastised if caught playing rounders. Birds nesting were also often chased away.

In 1951, the Lights of Leamington began as part of the Festival of Britain celebrations and lasted for eight weeks, from August to September. It was estimated more than 300,000 people countrywide visited them. The event was so successful it was repeated annually until 1961, being an escape from earlier wartime austerity. During these years the gardens were transformed into a wonderful fairyland of colour, illuminating flower beds, the lake, music and open-air dancing. On Saturday evenings there were fireworks. The earlier events used hand-lit candles in jars, later replaced with more sophisticated electric lights and time switches.

The LIGHTS * * * * *
* * * of LEAMINGTON

Nightly during AUGUST and SEPTEMBER
(Sundays excepted)

Lakeland Music * Riverside Beergarden
Special tableaux * Alfresco Light Refreshments
Fireworks Displays * Pavilion entertainment
Children's Features * Supper Buffets
Ballet on the Lawns

all amid

An Enchanting Fairyland
of Wonderful Illuminations
(See pages 18 and 19)

**Admission: Mondays to Fridays—Adults 1/6, Children 6d.
Saturdays— ,, 2/-, ,, 9d.**

Further Information from Spa Manager, Pump Rooms. Tel. 1017

'The Lights of Leamington' advertisement.

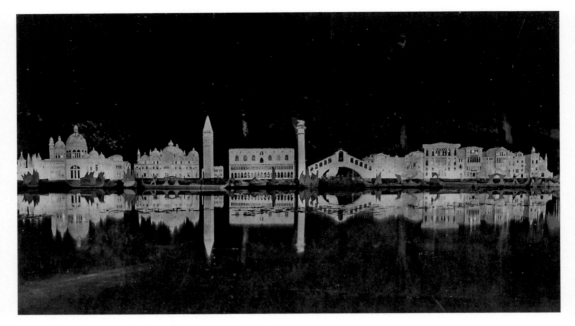

Lights of Leamington on the lake.

Pump Room Gardens

Although an integral part of the Pump Room, in true Leamington class-conscious style, these were not available to the public until 1869, and only then for a fee. The wealthy patrons enjoyed their picnics with servants waiting on them. Earlier attempts to make the gardens free were met with fierce opposition, and free access was not granted until 1875. As speeches were forbidden in the gardens, protesters delivered them from boats on the river.

Bordering them is Linden Avenue, which was begun in 1815 and was once known as the 'monkey run'. This was where the less wealthy could only look on at the picknickers on the other side of the fence. The crowns, arches and gas lamps were added in 1887 for Queen Victoria's golden jubilee. In 1901, drilling commenced in the gardens for another source of spa water. It was unsuccessful.

2. Accommodation

Wealthy visitors staying for the season needed accommodation and sustenance for themselves and their servants. It was an era of rapid house and hotel building, albeit with varying qualities. Here follows some of the constructions.

The Angel

In its heyday, the Angel stabled 100 horses. After a chequered history, it is now a thriving business. Part of the site includes the now demolished house where Private Henry Tandey was born. He won the Victoria Cross during the First World War and popular folklore maintains he saved the life of a certain Adolf Hitler during this conflict. In the 1950s a Labrador dog named Topper walked regularly to this hotel, where he was given a drink. After he had finished it, he ambled to the nearby taxi rank where he was known and given a lift home to Lillington.

The Bath Hotel

William Abbots, co-founder of the new Leamington, took over the New Inn during 1793, renaming it the Bath Hotel. When he died in 1805 his widow handed the hotel and baths to her son-in-law. He renamed them Smith's Baths until selling them for building plots in 1819. Smith continued selling the salts Abbotts had started.

The Bedford Tap

Opened in 1811 by John and Sarah Williams, formerly in service at Guys Cliffe House in Warwick. They recognised the need for hotels in the rapidly growing Leamington and seized the opportunity to be a part of it. Their new establishment provided fifty rooms with a small bar, known as the Bedford Tap, for servants. The hotel began as a sober and sedate business, but this changed after they built the Regent Hotel opposite. For instance, port was served in pint-sized glasses. In 1826, the Oyster Club was formed here. Members had to belong to the United Services Club or be gentlemen of fortune. In the same year the renowned eccentric Jack Mytton, also known as 'the Shropshire Squire', visited. For a bet, he rode his horse upstairs and they both jumped out of the window into Parade below. Apparently neither of them was hurt. The building later housed the Leamington Priors and Warwickshire Bank and remains a similar institution.

The Chair & Rocket

Situated in Bath Street, it is believed this inn's name came from the days when it was a theatre, taking its name from one of its first productions. It has also been known as the Jug and Jester and more recently the Old Library. The author remembers it from the

Left: Former Bedford Hotel.

Below: John aka Jack Mytton.
(Courtesy of Daderot)

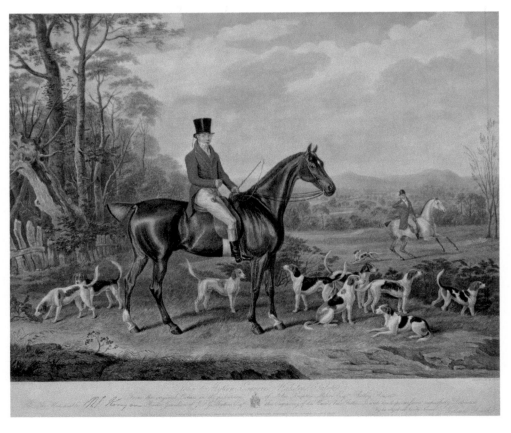

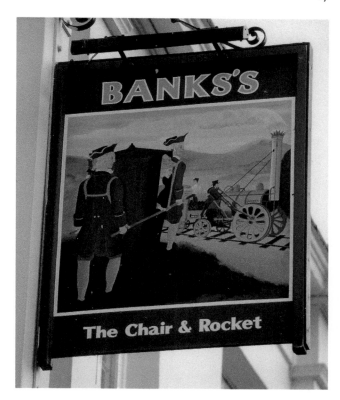

The Chair & Rocket.

early 1960s when there was upper shelving displaying numerous barrels and the licensee was Leonard Carver. In time he moved on to the Bell at Shottery and finally to the Throckmorton Arms at King's Coughton. Quite by chance the author was at a function there the night Leonard retired.

Clarendon Court
Often referred to as 'The Hotel of Distinction', this opened in 1832 in Lansdowne Place, now called Upper Parade, and always had a reputation for good service. The bar was a regular meeting place to sample well-kept beers served in pewter tankards, including Flowers Keg Bitter. In 1952, it boasted of having 'central heating everywhere with hot and cold water in all bedrooms'. A restaurant, grill room and cocktail bar plus private lock-ups and an adjoining garage completed its services. It was acquired in 1983 by the Warwick Commodities broker Keith Hunt, who suddenly vanished along with £6,000,000, and has not been seen since. Now known as Clarendon Court, the building contains twenty-four luxury apartments.

The Crown Hotel
This hotel, situated in High Street, has seen better days. During 1951 it boasted of seating for 100 guests in its 'beautiful dining room'. Each bedroom was supplied with hot and cold 'softened' water, a radiator and reading lamp.

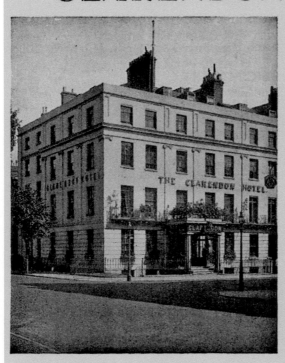

Above: Clarendon Hotel advertisement.

Left: Flowers brewery label.

THE CROWN HOTEL

LEAMINGTON SPA Telephones 1721-1730

LUXURIOUS BEDROOMS
each with hot and cold softened water, reading lamp and radiator

RESIDENTS' WRITING ROOM AND LOUNGE

BEAUTIFUL DINING ROOM
to seat 100 guests

Table d'Hote
Luncheons
and Dinners

Consistent personal
attention to the
comfort of guests

FULLY LICENSED

A.A.*** R.A.C.

Proprietor—
John Wilson

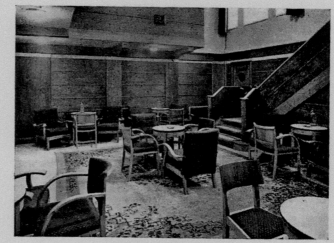

The Entrance Hall

Crown Hotel advertisement.

The Golden Lion

This establishment began life in Cross Street, later renamed Regent Street. Being one of the first buildings in the new town, in 1810, it was described as a 'common public house with accommodation'. Despite operating from an impressive address at the front, its rear was close to the notorious Satchwell Street slum area. One bar in an attached house was known as Uncle Tom's Cabin and described as 'the most disorderly house in Leamington'. Improvements were made in the 1880s and the enlarged cellar now held 3,000 gallons of beer. At one stage it was owned by the Leamington-based Lucas, Blackwell and Arkwright Brewery and later by Ansells, before closing in 1988.

Haunch of Venison

Situated in Parade, complete with its mock-Tudor front, opposite the town hall, it is now called House. In the 1960s there was an annual fencing competition held in the town hall, before later moving to the Spa Centre. Situated where it was, the Haunch was a popular venue with fencers during this era. The author first fenced here at the time of the new Coventry Cathedral being consecrated in 1962, complete with another Graham

Haunch of Venison.

Sutherland's tapestry. The fencing organisers refused to accept the author's application as genuine, believing it to be a hoax and it took time to convince them of his having the same name.

Jolly Brewer

Another popular Flowers public house situated in Guy Street; it was demolished in 1981. In the 1960s closing time was at 10 p.m. in Leamington. However, in nearby Stratford-upon-Avon, on Fridays and Saturdays, their closing time was 10.30 p.m. This often meant an early exodus from Leamington pubs over to Stratford to enjoy the extra minutes. It was doubtful if people gained any extra drinking time because of their travelling, but it was the principle of being legally permitted to have an alcoholic drink after 10 p.m.

La Plaisance 1896–1910

In the midst of Lansdowne Crescent, erected in 1835 at Nos 41–3, was this high-class hotel, which was a popular venue for long-term wealthy residents. It offered late dinners with home comforts at moderate terms. The front of this impressive crescent has hardly changed; however, it only looks good from the front. It is a much different story at the rear.

Manor House

Often referred to as 'Leamington's Exclusive Hotel', Matthew Wise's former family home, situated in 3 acres of private grounds, was built around 1740, becoming a hotel approximately 100 years later. Over the years it has also been a school, headquarters of the 29th Division during the First World War and a wartime hospital. During the Second World War it was occupied by the Ministry of Transport. Local organisations, such as the Leamington Priors Association for the Prosecution of Felons (see page 75), held meetings here until it closed in 2005 and became luxury apartments.

The Regent Hotel

The Bedford Hotel was such a success it soon became too small for John and Sarah Williams, and they moved to larger premises. Taking nine months to build, the Regent Hotel grew on the other side of Parade. Opening in 1819, 200 guests attended its inaugural dinner of turtle and venison. Three weeks later the Prince Regent allowed them to call it the Regent Hotel. It reputedly had 100 bedrooms but only one bathroom, but other estimates say it was just eighty bedrooms. Other accommodation had to be provided for guests who brought in their own staff. The original entrance was on its side and Parade portico was added thirty years later.

There were facilities at the rear for fifty horses plus carriages, and later motor vehicles. Ironically, although being used by the Camouflage Department, this part was damaged in an air raid during the Second World War, along with the stained glass on the main staircase, which has since been repaired. In its heyday, the Regent, with its magnificent staircase, was believed to be the largest hotel in Europe and visited by famous people from history. One of the earliest was the eleven-year-old Princess Victoria in 1830 – her first night spent outside a royal palace.

In 1918, a complaint was made to the chief constable about excessive smoke coming from a chimney, which the constable on point duty must have seen, yet made no report about it. With Leamington's growing popularity, there was an increase in tourists arriving. To minimise complaints about motor coaches (charabancs) parking on the roads, it was arranged in 1923 for them to park here.

A bridal couple held their wedding reception here in 1965, with a photograph taken of them on the staircase. They submitted it to a local media outlet for publication but were refused, the reason being that a picture of a bride and groom going upstairs was too suggestive.

Other changes included a lift that was decorated to resemble a library, its wall lined with book spines. The Phoenix Bar was developed in 1993, which told the Regent's story in a mural by a local artist. When it was the Vaults bar they produced their own matches for smokers. Despite all these improvements the hotel closed but was refurbished and in 2005 became a Travelodge.

The Royal

Situated at the junction of High Street and Clemens Street, the Royal went as far as Court Street. Michael Copps created it between 1826 and 1827 and included the old existing buildings already on the site. In reality, it was a range of buildings without

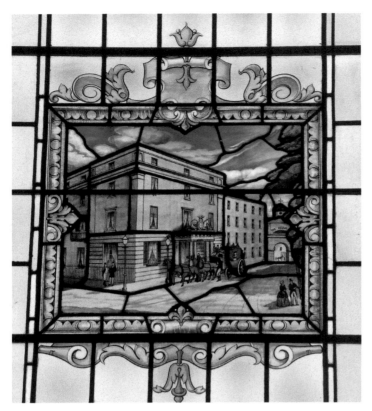

Regent Hotel
stained glass.

The Vaults matchbox.

uniformity, four storeys high with fifty windows facing the High Street. Outside had room for fifty horses and forty carriages. Michael Copps was a successful coach operator. Living on his reputation as a master chef, he boasted about selling real turtle soup at 14s a quart. When the hotel went bankrupt in 1841, its contents were sold. The sale lasted twenty-seven days and included fourteen tins of turtle and 4,363 bottles of wine. His basic prices were reasonable but excluded hidden extras such as use of public rooms, lighting, and heating. Was this why he went bankrupt? Following another unsuccessful attempt to run it as an hotel, it was demolished in 1847 for erection of the first of the railway bridges at this location.

Victoria House

Erected around 1834, Thomas Michael Copps, son of Michael Copps the elder, bought it as a hotel. It soon failed and has since had various owners. Today it is owned by freemasons. The occupations of its early members included bank clerk, comedian, chief constable, gentleman, performer, seed crusher, surveyor of taxes, and taxidermist. Until fairly recently the upstairs windows facing Willes Road appeared to have been been bricked up from the inside, either permanently or with a blind resembling a stone wall, effectively preventing their ceremonies being overlooked. These obstructions have been removed.

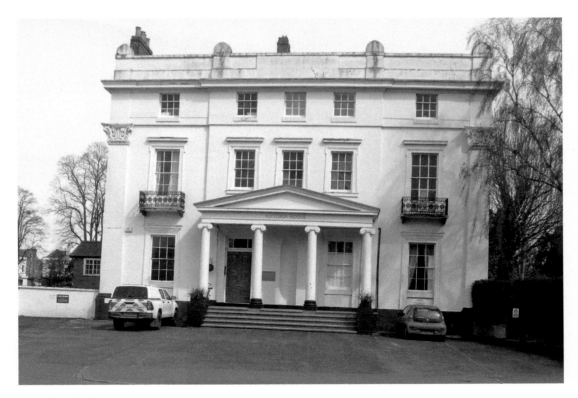

Victoria House.

Youth Hostel

In the 1950s this economical accommodation was situated at the junction of Willes Road and Leam Terrace.

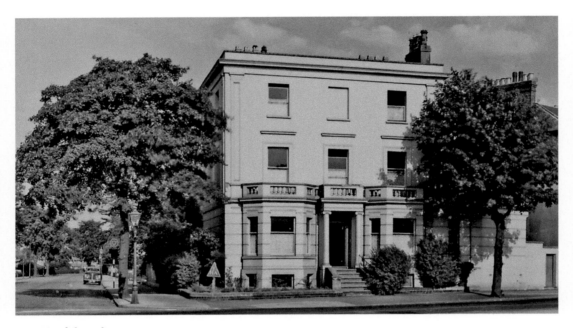

Youth hostel.

3. Entertainment

Taking the waters only occupied part of the day, so how did visitors spend the remainder of their time? Quite simply, it was in some form of entertainment, depending on their age and ability. Money was not a problem for most visitors. Spa towns needed to offer a busy and varied social life to survive and compete with their rivals. This was where Masters of Ceremonies came into their own. It was up to them to arrange entertainment for visitors to spa towns. If they did well, hefty tips appeared. What follows is some of the entertainment in Leamington up to the present day.

Assembly Rooms
The main assembly rooms opened in 1812 and hosted balls, concerts, playing billiards and cards, coupled with a reading room. They stretched from Parade to Bedford Street, and later became known as P. H. Woodward & Co. (see page 44).

Bath Assembly Rooms
Although not constructed in Spencer Street until the 1920s (to cater for dancing), this is an interesting building. Its most striking part is the figure of Terpsichore on the roof, holding a globe. She was one of the nine Greek muses and represents Dance and the Chorus. The author remembers going to dances there. It was a popular venue during the Second World War, but as tastes changed so did its use, including becoming a garage, dance studio, and conference centre. In recent times it has been hit with financial problems and controversial damage (vandalism?).

Lower Assembly Rooms
These were also known as the Parthenon and Royal Music Hall. They were constructed in 1821 in Bath Street opposite Regent Place. In 1873, they housed the public library. At the Parthenon there was a Saturday afternoon cinema for children, when movie films first appeared. During the intervals children enjoyed treacle-covered buns, which they held by an attached string so they could eat without touching them, thereby avoiding sticky fingers.

Cinemas
During the 1950s cinemas sometimes showed a certificate U (or Universal) film with a certificate A (or Adult) film. This meant youngsters could not see the U certificate film on their own but had to go with an adult. If no family adult was willing or available, youngsters waited outside the cinema and asked adult strangers to take them in, although they paid for their own admission. Imagine doing that today? The cheaper seats gave you a crick in the neck from looking up at the screen. Some cinemas had a thick white line

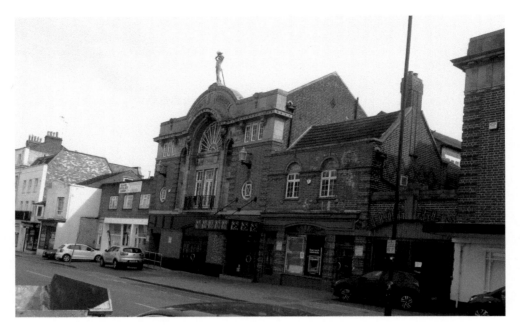

Bath Assembly Rooms and Terpsichore.

painted in the aisle, behind which were the more expensive seats. Once the lights were down, there was a mad scramble backwards to these better ones. The national anthem was played at the end of the evening, although most of the audience had pre-empted it by leaving before it started, even as the main film was ending. There were Saturday morning cinema clubs for children, which usually included a cliffhanger from the previous week, where the hero had been left in a precarious position. Their escape the following week was an anticlimax.

Many Leamington cinemas have come and gone, from the very first silent ones in temporary accommodation to the more modern ones today. Originally known as the Bath Cinema, Clifton was a purpose-built establishment in Spencer Street, opening in 1925 with *Scaramouche* starring Ramon Novarro. It took its name from the old bowling green at the rear of the Bath Hotel. The cinema was renamed the Clifton in 1938 when it was taken over by the Clifton Group. Although still standing, the cinema closed as such in 1982 and has been used for other businesses since then.

The building once known as the Regal still functions as a cinema, but now hosts more than one screen. Sadly, many of its original art deco features have gone. From 1931 to the mid-1950s, it housed the only Barbieri organ to be installed in any UK cinema. During the floods of 1998 when the Leam burst its banks, the Regal was flooded. Ironically, it was showing the film *Titanic* at the time, which starred the late David Warner, who had once lived in the town.

Between 1881 and 1935, the Regent was known as the Theatre Royal, before becoming a cinema complete with an organ. The theatre was heavily criticised in 1901 for performing Fred Karno's *Her Majesty's Guests* so soon after Queen Victoria had died. Fred Karno was

the stage name for Frederick John Westcott, who was the innovator of slapstick comedy, including throwing custard pies. It offended strait-laced Edwardians. In 1953, it showed *The Robe,* which was the first cinemascope film in Leamington. Like many other theatres and cinemas, it had a chequered financial history, including one owner who died on a Tube train in London. Before being demolished it was a bingo hall, and is now Regent Court.

Situated in Bedford Street between 1910 and 1952, Scala was a purpose-built cinema, known as the town's 'fleapit'. It began showing silent films, which were later accompanied by music from a single pianist. Lee Longlands is now situated on its site.

Circus

Whenever a circus arrived in Leamington the performers always processed through the town, often performing at the bottom of Tachbrook Street. They were more like a visiting fair with exhibitions and peep shows.

George Wombwell was the promoter of lion versus dog fights, such as in 1825 at Warwick. He also displayed his travelling menagerie in Euston Place during 1836. Working with animals ran in the family, but not always successfully. His nephew, William Wombwell, was killed at Coventry in 1849. He had tried to stop two elephants fighting by prodding one of them with a knife. The elephant turned on his new assailant and gored him to death. George's granddaughter, Ellen Eliza Bright, known as 'the Lion Queen', was killed by a tiger the following year at Rochester. George is buried in Highgate Cemetery.

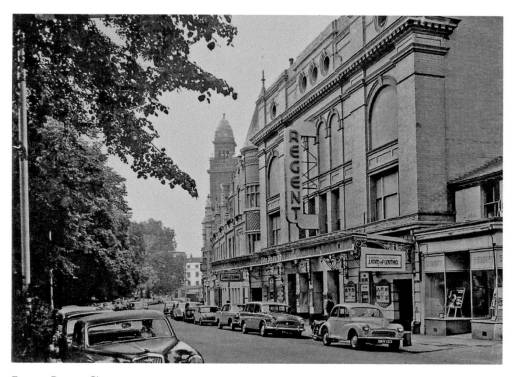

Former Regent Cinema.

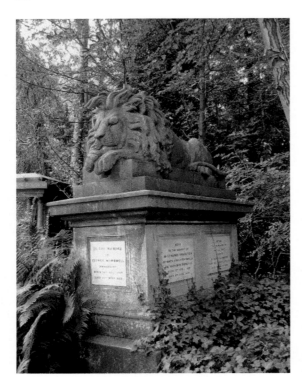

George Wombwell's tomb, Highgate Cemetery. (Courtesy of Nicholas Jackson)

Music

In addition to the events in the Jephson Gardens, the Pump Room Gardens held regular concerts. Despite the free entry an attempt was made to close off the area around the bandstand unless visitors were prepared to pay for the privilege. The proposal was dropped, but the organisers were permitted to charge for the use of seats and deckchairs.

Radio

Norman Painting was born in Grove Street in 1924 and educated at Leamington College and Oxford. He is best known for playing the role of Phil Archer in the radio series *The Archers*, for which he wrote more than 1,200 scripts.

Children's Hour first appeared on the radio before the Second World War. The animal talks were given by Gladys Davidson, who also wrote prolifically about them and ballet. Gladys lived in Leamington with her sister Gwen. Their father, Robert, had been the borough surveyor.

The writer Francis Durbridge created the character Paul Temple, who has since appeared in film, radio and television productions, originating in 1938. Temple was a gentlemanly private detective, and the programmes were introduced by the haunting melody called the 'Coronation Scot'. It is believed its creator got the idea from listening to a train gathering speed. Francis Durbridge was on a train from Snow Hill, Birmingham, to London, which stopped at Leamington. Here he saw a man leave the train who gave him the inspiration for *Paul Temple*. He never knew the man's identity.

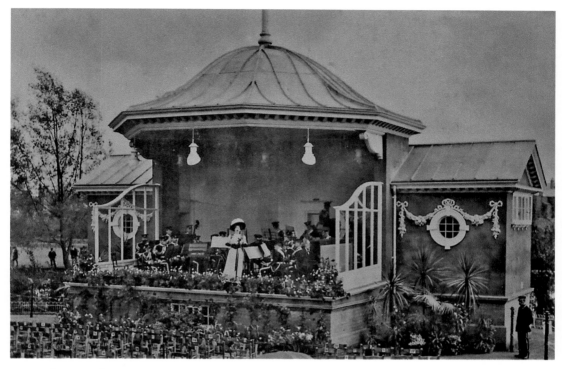

Jephson Gardens concert.

Royal Spa Centre, Harrington House (now the Spa Centre)

Harrington House had been built by Edward Welby Pugin, son of Augustus Welby Northmore Pugin and designer of more than 100 Roman Catholic churches. When it was built the house contained a private chapel. An owner in the early twentieth century worshipped in Christ Church and invited their choir to visit Harrington House at Christmas. It was taken over in 1939 as the local Civil Defence headquarters and used for the Women's Voluntary Services training, but not for long as the Czechoslovakian Brigade used it.

The house was purchased in 1949 by Leamington Borough Council and the Royal Spa Centre was born. Opened in 1972 by local MP Anthony Eden, it is very much an example of brutalist architecture, having concrete panels. The venue has multiple uses including as a cinema and for sports, music and lectures.

DID YOU KNOW?
It is rumoured that Hitler intended to move into Harrington House when he conquered England and use the Jephson Gardens as his own.

Sport

Boating

Mill Gardens were the location of this popular Victorian and Edwardian pastime. It is easy to imagine the gentlemen in their straw boaters and striped blazers, punting their ladies around on the water. A special lock was created to bypass the suspension bridge into a lower part of the Leam.

Bowling

The main club in Archery Road opened in 1913 and hosts annual bowling tournaments, including the Commonwealth Games in 2022.

Boxing

The latest boxing hero from Leamington is Lewis Williams, Commonwealth Games 2022 champion. Prior to him, that honour was held by Randolph Adolphus Turpin, who was born in Willes Terrace in 1928 and became a World Middle Weight champion. Randolph acquired the nickname of the 'Leamington Licker' and is well remembered for defeating Sugar Ray Robinson. Sadly, he died by suicide from shooting himself in the head and heart in 1966 at his café premises in Russell Street. When his statue was made available, Leamington did not want it, but Warwick did, and that is where Randolph rests today.

Curling

Welch's Meadow, off Willes Road, has long been the venue for this winter activity, provided the Leam has flooded and weather is cold enough for it to freeze, as in February 1901.

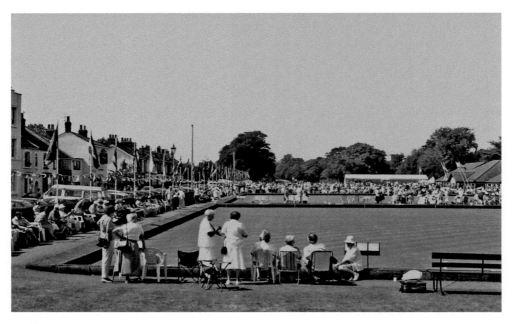

Bowling.

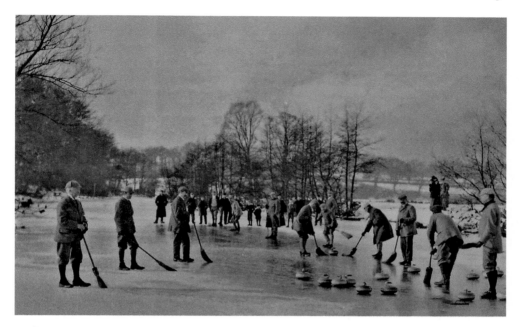

Curling.

Horse Racing

The year 1834 saw the first steeplechases held at nearby Ashorne. Here, Captain Martin William Becher on Captain Lamb's horse, Vivian, beat the Marquess of Watford's Cock Robin. The Fox and Vivian inn commemorates this event. Becher was an eccentric horse rider who is credited with naming Becher's Brook, into which he fell, in what would become the Grand National. He was a popular character who loved telling stories, particularly after leaping on the mantelpiece with a standing jump.

Ice Skating

There was an early rink in Colonnade. The alternative was to wait until the lake in Jephson Gardens froze. How long they stayed depended on when the park keeper arrived to chase them away.

Rugger

The town's club began life on land just off the Old Warwick Road before later moving to the Kenilworth Road. The old clubhouse, complete with communal baths and its own bar, selling Flowers beers, was situated on the other side of the canal. For the pitch nearest, this meant an extra hazard of the ball sometimes going into the water. Then someone – preferably the person who had kicked it there – had to swim and fetch it out.

Swimming Baths

When these opened in 1890, councillors were sceptical about them being used, but they outlived their critics. Originally attached to the Pump Room, they have now been moved

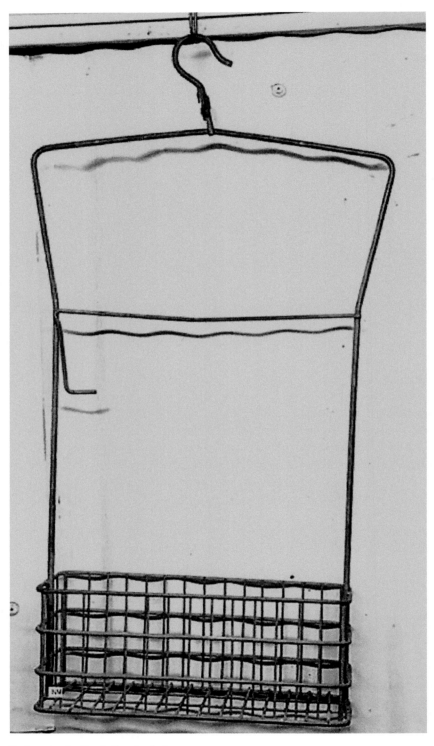

Swimming baths clothes basket.

to the Campion Hills. The original baths now house the library, museum, and adjoining art gallery. Entry was via the Pump Room Gardens along a glass-covered area, where newsagents operated on Sundays. Behind them there was a large wall-mounted map, which covered the Midlands and was a source of useful local information. Once inside, bathers used wooden changing cubicles complete with hanging metal clothes baskets. This was once the largest covered pool in the Midlands where countless people, including the author and his family, learnt to swim.

Tennis

The first proper lawn tennis match was close to the Manor House Hotel in 1872, on land that has since been converted into housing. Its participants were Major Harry Gem and Mr J. B. A. Pereira, a Spanish wine merchant from Avenue Road. The celebratory centenary

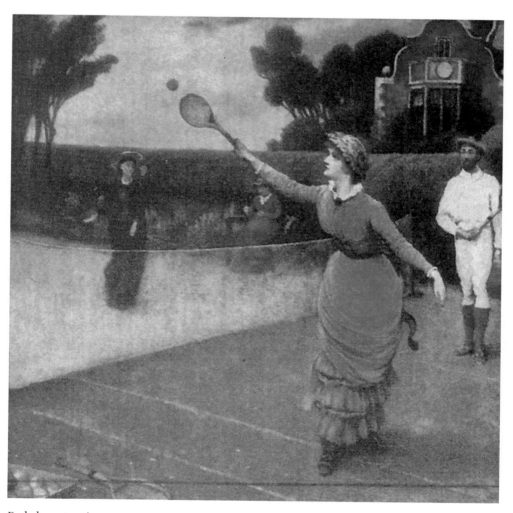

Early lawn tennis.

match had to be played in front of the hotel because the original site now housed Manor Court apartments.

The much older version of tennis (real or royal) began in medieval France but declined in the eighteenth century. There was a revival in the Victorian period, however, and Leamington planned its own court to accommodate the growth of wealthy visitors. Despite being originally planned for Holly Walk, the court was erected in Bedford Street during 1846. There is another court in nearby Moreton Morrell, allegedly built by an American millionaire who had been refused membership of the Leamington one.

Television
With a wide variety of buildings, Leamington and its surrounding area has been a popular venue for television productions. Among these are *The Expert: Dalziel and Pascoe,* which includes Clarendon Square and the old police station; *Upstairs, Downstairs* in Clarendon Square; *The Locksmith* in Lansdowne Crescent; and *Keeping Up Appearances* in various locations. Just recently, Clarendon Square became a venue for the mini-series *Three Little Birds* – yet to be released.

Theatres
Stage performances were always popular in Leamington's early days with no television or movies in existence. Any suitable building sufficed, such as the Chair & Rocket.

Theatres like cinemas come and go, yet the Loft has stood the test of time, albeit not without problems. The Leamington and Warwick Dramatic Club first met in Warwick in April 1922. Afterwards they used different venues, such as the Golden Butterfly Restaurant and the Labour Exchange in Holly Walk. Their first production was in an old loft in Bedford Street during 1923 with *The Silver Box*. They would now be known as the Loft Theatre. When this building was demolished in 1941, they moved to the Colonnade, into really what was just a shed. A one-time home for a cinema showing silent films with music and a roller-skating rink were among its earlier uses. The Loft did not have it for long as the premises were taken over by the Camouflage Department.

Once the theatre was acquired in 1945, there was a shortage of chairs. Replacements were secured in Stratford and a host of volunteers drove over there to bring them back to Leamington. A fire in 1958 caused more problems, but despite these and other setbacks, the Loft is a thriving concern in the Colonnade.

Loft Theatre.

4. Trade and Retail

Leamington's first shops appeared in the High Street area around 1780, then known as London Road. As the town grew, small enterprises providing food, drink, glass and crockery set up in Parade. These spread into Warwick and Regent streets and set the scene for the future. Markets were another important source of food and other necessities.

Burgis and Colbourne

Originally called the Bedford Stores, it was popularly known as B&Cs, and still is occasionally today. Charles Richard Burgis and James Colbourne formed it in 1872, beginning in Bedford Street. They later acquired the former Athenaeum Library in Parade, which became their main entrance. Although a successful enterprise, they were unpopular

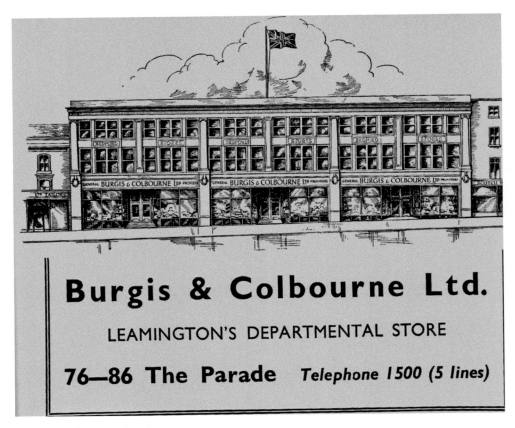

Burgis & Colbourne advertisement.

with smaller businesses who could not compete with them. They quickly became a department store selling all manner of goods. For instance, in 1901 they sold their own beer under the name of Bedford Ales and Stouts, which cost 2s 6d (approximately £9.70 today) per dozen. They also sold equipment for lawn tennis, croquet, golf, and bicycles. Their upstairs restaurant became a popular venue for morning coffee and other meals.

Back on the ground floor was a fresh-food counter with a wonderful aroma, where only items such as jams and marmalades were prepacked; everything else was cut or weighed to order. Having left Leamington in the 1960s, the author seized every opportunity to visit and purchase their custard and treacle tarts. He once left them unattended in his car and discovered on returning that his boxer dog also had liking for them. They were always put in the boot afterwards! Since 1963, the stores have had various owners and now in 2022 the premises are empty.

Bobby's

Frederick Bobby from Margate opened this store in 1921. He owned other stores in the UK, which by the 1970s were part of Debenhams. Bobby's was an elegant department store with great window dressings of all colours selling a wide variety of goods. It was an immensely popular venue during rationing, and regularly enjoyed long queues. During the Second World War, Bobby's coastal branches sent some of their staff to safer postings in Leamington. This store was damaged during an air raid, which resulted in a sale of damaged goods. The author once heard someone describing their upmarket restaurant as 'Bob's Caff', which was not a fair comment.

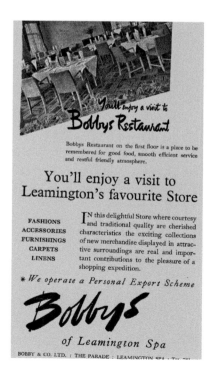

Bobbys advertisement.

Bobbys.

Boots

Situated opposite Euston Place, these premises were smaller than today's venue on the corner of Warwick Street. In addition to selling medicines, they also sold books and operated a lending library. These books all had Boots stickers on them and belonged to Boots Booklovers library. Their main competitor, Timothy Whites Ltd, remained nearby in Parade until Boots acquired them in 1968.

Cadena Café

Facing the town hall at Nos 134–36 Parade, these premises were part of a group founded in 1895 who operated in the South West and Midlands. This branch specialised in roasting and grinding their own coffee, and its wonderful aroma wafted out into Parade and drew people inside. It was a great place to meet for coffee, and customers had to pass through the front where the loose coffee was sold to get to the room at the rear. The company was acquired by Tesco in 1965.

Chimes Barbers

Situated in Church Street, once known as Church Lane, these premises were home to a barber shop owned by Bob Chimes from Malta. He also played in a local band called the Serenaders. In 1955, his daughter Jennifer was Miss Great Britain. The author remembers having his hair cut there as a youngster and being entertained by horror stories of the injuries he received in a vehicle crash and by being bayonetted during his military service. He never knew if they were true or not.

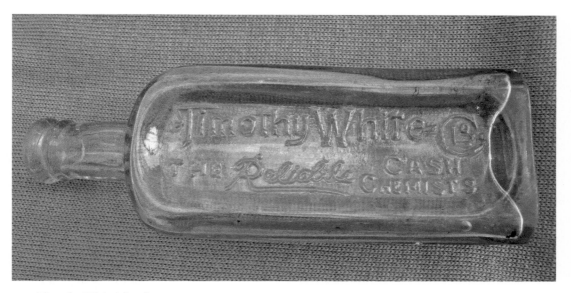

Timothy White's bottle.

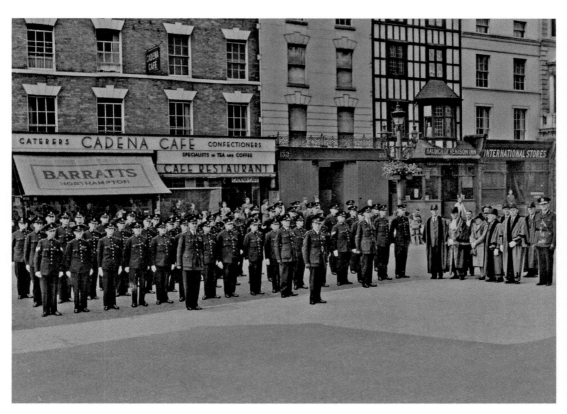

Members of the Special Constabulary are shown here receiving medals at the Cadena Café. (Courtesy of Terry Gardener)

Chimes.

E. Francis & Sons

Frederick William Francis opened his drapery store in Bath Street during 1840. The business went from strength to strength until it closed in 1980. Like other stores in town, it sold quality goods. He took over Smith's Baths and demolished them, making room for his new department store. This quickly expanded thanks to the arrival, popularity and progress of the railway. Emma took the business over and renamed it E. Francis & Sons when her husband Frederick died in 1855. Her sons continued the business following her death. The family lived over the premises with their own garden at the rear. Expanding the business meant more employees, many of whom lived on the premises, where the sexes were strictly segregated, and they had to move out on becoming married. The average working day for their employees was twelve to thirteen hours, and even longer for dressmakers. Majestic Wines are now on the rebuilt site.

A regular customer was Frances Evelyn Greville, née Maynard, Countess of Warwick, also known as Darling Daisy. She regularly gave presents to the staff and was a popular visitor. The store employed a uniformed doorman who was always advised of her coming. On a particular morning in 1914, she found the store owner waiting for her. He greeted her coolly, advising there was nothing of interest for her in his store that day. Daisy realised she would get no more credit from there as she owed him too much money. The next few months were a massive problem for her as she tried to raise money. One idea was to sell

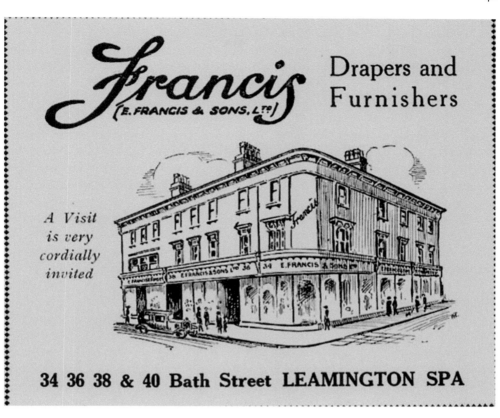

Above: Francis advertisement, 1929.

Right: Darling Daisy.

to the royal family or, more correctly, blackmail them into buying from her a series of very embarrassing letters. These concerned the affair she had with the late king, Edward VII, when he was Prince of Wales. The beginning of the First World War put paid to that idea, but she found a way out of her difficulty.

Kinmonds, Kenilworth Street

This company's site is now a retirement complex, known as Kinmond Court, and was once used by Griffin & Steel. J. Daily from Regent Street realised there was a market for providing bottled spa water for drinking and not just bathing activities. Originally operating from Regent Street, his business was purchased by the Kinmond family, from Perthshire, in 1871. Having acquired access to the high-quality saline water from the Pump Room, the business thrived. When the Kinmonds purchased the company, Daily made an agreement with them not to sell similar products within a 50-mile radius of Leamington. When he broke this, they took him to court and won. In addition to selling spa water worldwide, they expanded into soda water and lemonade before ceasing business in the 1960s.

Leamington Priors Gasworks

The idea of lighting all of Leamington's streets by gas lamp was dismissed as impractical, but these gasworks were in place by 1822. Coal arrived via the canal and the first operating streetlights appeared in the Old Town. A celebratory hot-air balloon flight in 1824 used gas from here. Later known as the Leamington Priors Gas Light and Coke Company, it provided gas to light the whole town, and was purchased in the early 1900s by Leamington Council when ten 'A' shares in the company valued at £200 were sold for £47 10s each. They were taken over in 1948 by West Midlands Gas Area, and houses have

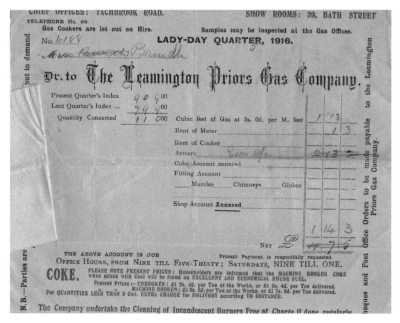

Leamington Priors Gas Company invoice.

since been built on the site. The letters 'LEAMNTN', short for Leamington, were painted on the gas holders as an extra navigational aid for aircraft pilots.

WHSmith

An iconic name that has been long associated with newsagents. The original Leamington branch was one of the first national stores to open circa 1885. Its sign was a familiar landmark for years. The front of the shop sold newspapers and magazines and other items, while the inner part was reserved for books. Today's premises are much larger than the original ones and have moved further up Parade.

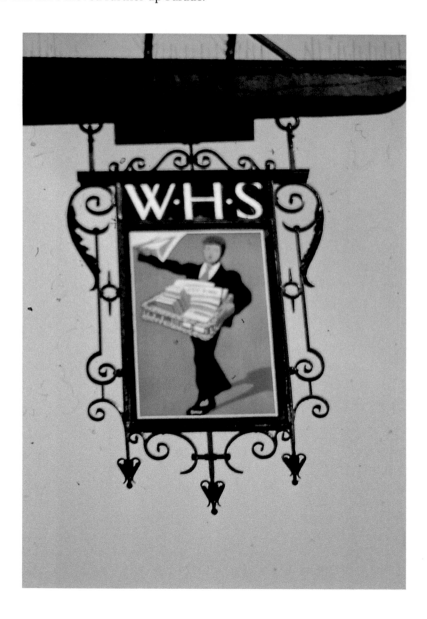

WHSmith sign.

H. E. Thornley Brewery

Although not actually in Leamington but in nearby Radford Semele, their brews were readily available in town and at temporary bar facilities at events. They had a large advertisement on one of the bridges at the bottom end of Bath Street, which has now gone. The brewery started in 1899 before being taken over by Ansell's, closing in 1968.

P. H. Woodward & Co. Ltd

Opened in 1812 for £10,000 as the Upper Assembly Rooms and funded by local businessmen, it was the venue for entertainment such as playing cards and billiards for almost 100 years. In 1908, the premises became Woodward's department store. Today this is another department store that has closed. They were a typical store, created from the previous smaller shops, and sold most items but also specialised in carpets and furnishings. During the mid-1970s the author purchased a carpet from there that they measured incorrectly and was far too short. Going in to complain, he went straight to the salesman who had made the arrangements. He was talking to other assistants, but when they realised why the author was there they vanished very quickly, leaving the unfortunate salesman on his own. To be fair to Woodward's, the matter was sorted out amicably and efficiently.

At one stage they had a monopoly on supplying school uniform. When the concession ended, one or two of the old-time staff still tried to insist they were the only ones who stocked the correct uniform, regardless of what the schools might have said. Heated arguments were not unknown between parents and dictatorial staff.

They are well remembered for their cash arrangements, at a time when stores and many shops operated a central paying system. If on a single level, they had a system of overhead cables with cash pots attached. The sales staff took the customer's money and put it into one of these pots, which was sent along the overhead cable to a central desk that housed the cashier. They sat there like a giant spider in the middle of the web of all these cables. In fact, they were often referred to as 'Spider Ladies'. These cashiers received the money, booked it in, issued a receipt and change, and sent the whole lot back to the sales counter. Woodward's were laid out on different floors and mezzo landings, so this method was impractical. Instead, they operated a system of pneumatic pipes and containers for the same purpose of going to a central cashier. Inevitably, there was a wait until a hissing, popping sound heralded the return of the container.

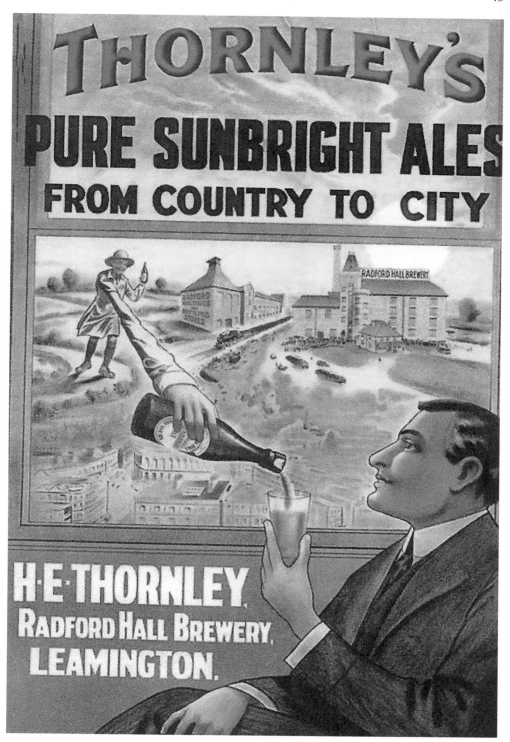

Thornley's brewery.

P. H. Woodward.

5. Communications and Transport

Parade

Parade is the main thoroughfare, linking the old and new towns, and was regarded as being sacred by the nineteenth-century townsfolk. Someone described it as being 'held so sacred they would put it in a glass case if they could'. Nevertheless, it was used by private and public transport, and still is. It was even suggested 'working men and their wives should be banned from it'. With the mid-nineteenth-century growth of shops, common sense was needed over this suggestion. The purists fought a losing battle, especially when the town hall was built. At the same time, they conveniently overlooked the state of the property and inhabitants in the neighbouring streets.

Air

The year 1937 saw the beginning of hydraulic systems being made at the local Automotive Products – initially for passenger aircraft, but not for long. This changed in 1939 when aircraft manufacture came under government control. Post-1945, the Warwick district was considered for housing a new airport, but it did not happen.

Joan Alys Helen Mary Parsons lived in Avenue Road. She left home one morning in 1938, telling her family she was going to visit friends in Reading, which was quite untrue. Instead, she flew a Miles Sparrow Hawk airplane to South Africa and back on her own. During her flight, Joan had kept herself going by eating spa water toffees. These were popular and made in premises close to the Aylesford Well.

Buses

The depot in Old Warwick Road opened in 1922 for Midland Red vehicles, which were owned by the Birmingham & Midland Motor Omnibus Company. By 1935, they had a comprehensive timetable of local services and were one of the largest in Great Britain. Today Stagecoach runs the service.

The Stratford-upon-Avon Motor Services, better known as the Stratford Blue, also operated in the area. They began as the Leamington and Warwick Tramway and Omnibus Company in 1880, operating their first tram the following year. Then they moved from trams to buses before the company was dissolved in 1977. Although buses in Stratford Blue colours can be seen around today, they are modern versions. At one stage there were plans for a trolleybus service, but these were abandoned.

Canal

The Grand Union Canal was once an important routeway coming through Leamington, providing transport for all manner of goods. In 1901, Leamington Council's policy was to use it to send refuse to a new sewerage at a cost of 1s 9d per ton. The heat created by its destruction saved the council £200–300 per annum.

Left: Midland Red timetable.

Below: Model of Stratford Blue bus.

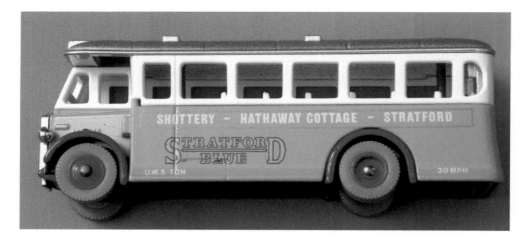

Coaches

With the growth of Leamington occurring at the same time as coach travel, the town soon became a popular visiting place. While the gentry had their own transport and staff, other visitors needed to rely on public transport. Not all wanted to use the canal flyboats, which travelled non-stop, and the railways had yet to arrive. The only alternative to walking or riding was to come by coach.

Until 1784, it had been a lengthy process, but thanks to John Palmer from Bath this means of travel changed when he invented the mail coach, which revolutionised horse-drawn passenger transport. Speed became all important and led to less scrupulous coach proprietors ignoring the traffic regulations of the day. A speedier service improved delivery of the first edition of the *Courier* to London on 9 August 1828. In the second decade of the nineteenth century, inside seats from Leamington to Warwick cost 1s. The

coaches all had names too. In 1828 *The Royal Leamington Eclipse* travelled from the Royal Hotel to London in ten hours, having started in Birmingham, and only used two drivers.

The arrival of Michael Copps in 1814 brought new life to the industry, operating from his opulent Royal Hotel, where he also had horses for hire. Former coach proprietor and transport contractor Amos Packwood retired and became a grocer in the Binswood area on the outskirts of town when the industry declined. *The Birmingham Tantivy* coach began running from the Bedford Hotel in 1833, which gave rise to the song when the railways took over from the coaching business: 'Let the steam pot, hiss till it's hot. Give me the speed of the Tantivy Trot.'

When railways arrived forward-thinking proprietors geared their timetables to coincide with the trains, which could not go everywhere, and alternative transport would be needed to and from their stations. Until the 1920s, two horse-drawn pleasure coaches ran daily from the Regent Hotel.

Horse-drawn transport was replaced by charabancs, and later by motor coaches. Charabancs appeared in France during the nineteenth century and were originally horse-drawn. By the 1920s they were mechanised and a regular feature on England's roads, although not always wanted in towns. So, it is easy to see why their appearance on Parade did not go down well among the purists. Parking in Newbold Terrace led to complaints. One remedy was to park at the Regent Hotel and Priory Garage in High Street for 2s a day.

By 1954, the Midland Red operated a coach service all over the Midlands and coast during the summer months. They also offered longer 'Coach Cruises' of between seven and twelve days. Not to be outdone, Priory Garage and Coaches Ltd offered daily tours from their High Street depot every day during the summer. Coach parties also came to Leamington.

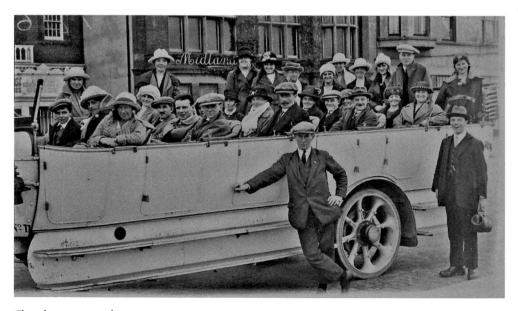

Charabanc at an unknown venue.

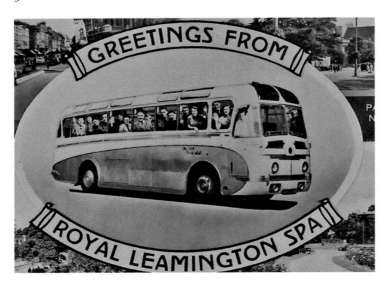

Tourist coach, *c.* 1966.

Motor Vehicles

As early as 1908 complaints were made about motor cars stopping on Parade outside shops. They were permitted to remain there for ten minutes before being moved on, although they could return 'in a short time'. Offending cars and motorcycles parked there were reported. Earlier complaints involved speeding motorists.

In 1898, Charles Crowden moved to Packington Place where he developed a motor vehicle that first appeared in 1903, followed by others. He moved to Kent two years later but still kept a business interest in the Midlands.

By 1913, two police officers were regularly employed on point duty on Parade wearing white gloves and could not leave their posts until relieved. They were assisted on Fridays and Saturdays by Royal Automobile Patrolmen who directed traffic in the Kenilworth Road at Lillington Avenue.

Parking of vehicles has always been a problem, be it on Parade or elsewhere. The basement of a property in Clarendon Square has been converted into use for parking cars.

Post

Benjamin Satchwell was postmaster when he discovered the spa water. Since then, Leamington's post office has moved locations over the years. In 1870, it was situated in Priory Terrace with a staff of twenty. They dealt with 170,000 letters and 5,500 parcels per week, being open until 10 p.m. daily, but closed at 10 a.m. on Sundays for church. These premises were burgled in 1901, but the staff had removed all the money and the thieves missed postal and money orders.

The first women were employed here during the First World War. At the same time Warwick was horrified to discover the Leamington was taking over their postal link, considering it to be undignified. During the Second World War the post office had its own division of the Home Guard. The building closed in 2013 and has occupied other homes since.

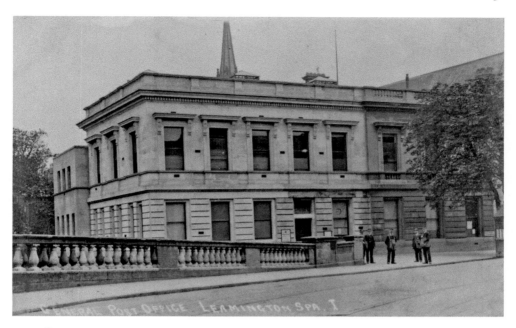

Post office, *c.* 1914.

Postmen wore blue frock coats with scarlet collars and cuffs, which accompanied their waistcoats and scarlet-piped trousers and caps. Badges and buttons were gold coloured. The first postboxes appeared in 1853 and had very precise times of collections, such as 10.23 a.m.

Railway

Leamington once had three railway stations: Main, Avenue Road and Milverton. The first train to arrive came from Coventry in 1844 and terminated at Milverton. The line was later extended to Avenue Road station further in town and was taken over by the London & North Western Railway by 1854.

The Great Western Railway arrived in 1852, initially in Eastnor Terrace, with houses being demolished. There was considerable opposition to it and its opening was delayed when the train bringing guests from London collided with a goods train. Another special train developed engine problems, which meant the banquet at the Regent Hotel started at 4.30 p.m. instead of 3 p.m., with Birmingham guests not arriving until 5.30 p.m. 'when the best food had gone'. Brunel oversaw the work, but after its opening people discovered the fares to Birmingham were cheaper on other services.

A building demolished for the railway's arrival in Leamington was the Royal Hotel. Here two bridges were erected, and ever afterwards the area was known as 'the Bridges', and still is, although one of them was removed in 1968. For years it bore the Thornley's Brewery advert from the time the railway had passed close to their premises in Radford Semele. In 1900, the police were instructed to pay attention to the out-of-work men and other 'unruly persons' loitering there.

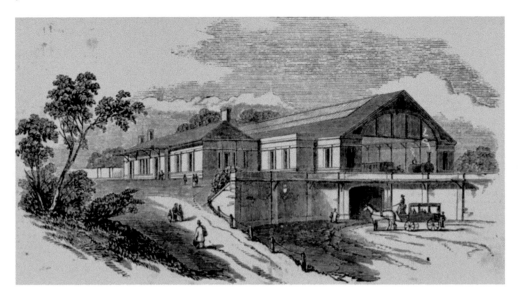

Main railway station.

Milverton station was the point of departure and return for troops fighting in the South African War and the two world wars. Many were taken there by public transport, but the returning troops marched back to Warwick in 1901, to the annoyance of several road users. Nearby is the public house that is now the Fat Pug but was previously the Coventry Arms and the Railroad Inn. It was built for the railway navvies working on the Milverton site. The station has had several names, including Warwick (Milverton) before being closed by the Beeching Axe in 1965. Cattle were transported once a fortnight and unloaded here. On one occasion Edward VII arrived here complete with his horse before riding to Warwick.

The main station was created in the 1930s and is an attractive art deco building, complete with benches showing the GWR logo. At one time everybody going onto a platform needed a ticket, including non-travellers. During the Second World War, the author can remember waiting on the platform and seeing hundreds of servicemen disembarking there from trains. In the 1950s, when he was sent to stay with an aunt in London, he travelled on his own, albeit with the guard in his van who had been handsomely tipped for allowing such a passenger.

In the earlier days trains were reputed to wait for important passengers if they were running late. During the early 1960s the author travelled from here to Birmingham every day. Going was not a problem, but returning was. The ideal way was on the London Express coming from Wolverhampton, which was rarely – if ever – on time. Travellers chose between waiting for it or catching the stopping train, which left ten minutes later. It usually paid to wait, as the stopping train could be moved into a siding to let the express pass. Sometimes in the morning he had to run after the train just as it was leaving and clambered on board. He was unaware how in 1901 a man had been fined 10s with 10s costs for doing just that.

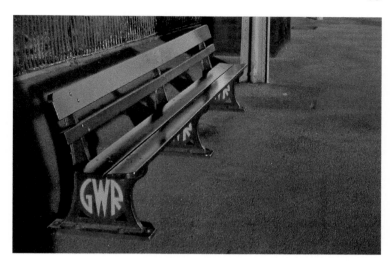

GWR bench.

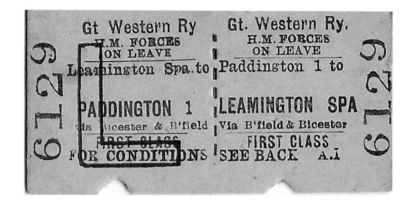

GWR HM Forces
on Leave ticket.
(Courtesy of C.
Hilton)

Model goods wagon.

GWR Rules & Regulations.

Direct services to Hamburg were operated from here in 1901 by the Great Eastern Railway using the Steam Navigation's fast passenger service *Peregrine* and *Hirondelle* on Wednesdays and Saturdays. Passengers arrived at Harwich for 9.25 p.m. where a first-class single fare cost £1 17s 6d and a return was £2 16s 3d. Second-class fares were £1 5s 9d and £1 18s 9d.

Trams

There was great opposition to a tram service using the 'Sacred Parade', with opposers arguing it would disfigure it. The complainers lost their battle, however, and the tram service began in 1880. Eight cars ran daily during this first year. The exception was Sunday when just one worked. Twelve months later fifty-two cars ran, with sixteen on Sundays. An extra two horses were needed to pull the tram up Parade. It took forty minutes to travel to Warwick. Aldermen Wackrill and Bright were responsible for instituting the service, whose early vehicles rattled along. They quickly earned the nickname of 'Wackrill and Bright's Rattlesnakes'. The main Leamington terminus was opposite the Manor House.

In 1905, modernisation arrived, and horse-drawn vehicles were replaced with electrically operated ones, despite opposition. These new dark green and cream tramcars carried forty-eight passengers and existed until 1930. The new system brought problems, however. For instance, while the old tramcars drove underneath the railway bridge by Milverton station, it was too low for the cables and there was no room to reroute the rails. The remedy was to dip the tram pole while going under the bridge. When the trams finally finished many of the cable holders became streetlights.

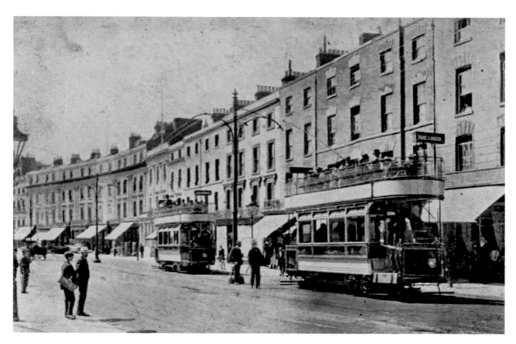

Trams.

An unforeseen problem occurred in November 1906 following a severe gale. A telephone wire was blown across the electric tram cables. A constable was seen to pick up the broken wire and put it in a nearby garden. He had done this with his bare hands, and nobody could understand why he had not been electrocuted. His knowledge of electricity in 1906 would have been very scant, if anything at all. The chief constable instructed when this happened in future, the cable was not to be touched until the arrival of someone with an 'India Rubber Glove'.

DID YOU KNOW?
A woman was cautioned in 1901 for carrying baskets in a perambulator instead of her child.

6. Religion

All Saints Church

The original founding date of All Saints is unknown, but a priest was mentioned here in the Domesday Book. As Leamington grew, All Saints became too small and the first extensions began in 1816, but the congregation soon outgrew them. Leamington's founders, Benjamin Satchwell and William Abbots, are buried here. In 1843, the controversial vicar John Craig began a large reconstruction and enlargement project.

Although one of the biggest parish churches in England, it is considered to be 'a fairly uninteresting design' despite its rose window being modelled on St Ouen Cathedral at Rouen. Further improvements followed, including demolishing buildings in the immediate vicinity. Not all these changes were popular or effective. By the mid-1870s, All Saints was still not big enough and the town's growth meant more churches needed to be built. Craig planned to have three towers, but the idea was abandoned as the columns in the nave were not strong enough to hold them. It would be 1902 before the work was completed, when Mrs Urquhart paid for it.

Craig came from St Mary's Church, Fetcham, Surrey, which he swapped with Robert Downes, then vicar at All Saints in 1839. Robert Downes had 180 burial vaults constructed for sale, with spikes and iron gates to deter bodysnatchers. Craig paid him £1,000 as compensation for loss of rent from the pews. Although All Saints was Craig's main church, he was also involved with others.

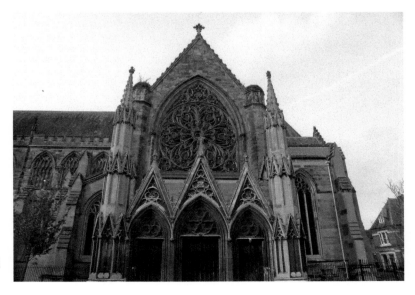

Rose window, All Saints' Church.

He was welcomed at first as he had money, thanks to marrying well. Unfortunately, being a controversial and arrogant individual, he caused numerous rifts and complaints and ignored advice whenever it suited him, despite some of his plans being completely impractical. One example was his insistence on using local sandstone, which is soft and a poor building material.

Craig spent time and money indulging in his hobby of astronomy, part of which involved him constructing a telescope at Wandsworth. He spent more time here than

All Saints' Church foundation stones (police in white helmets). (Courtesy of Terry Gardener)

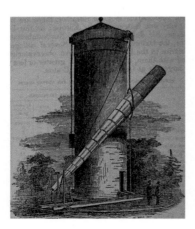

Craig Telescope, Wandsworth Common.

overseeing the building works in Leamington. For some unknown reason he kept no accounts, which resulted in his spending a month in prison for mishandling the funds. In poor health during the 1850s, he left his curates to oversee the project, which did not endear him to the parishioners. They wanted the work finished. He died in 1877 after a prolonged illness and a leg amputation, following unfounded allegations of preaching while drunk.

Before Craig arrived, the practice was to snuff out the church candles and put them, still smouldering, into a tin tobacco box. The practice ceased after someone put gunpowder into the box, which exploded when a smouldering wick hit it!

In the 1950s Canon Streatfield was the vicar and he lived in Leam Terrace. He was a tall, gaunt figure, often seen striding down to church with a black cape and hat, and quite scary to meet in the dark. In his free time, he kept a selection of stones on his bedroom window ledge for propelling at any creatures, such as cats, that trespassed onto the garden's vegetable patch.

Christ Church

Also known as Leamington's Episcopal Chapel, this was situated in the area once known as Beauchamp Square, at the top of Parade. It was built when there was no other Anglican church in this part of town. Opening in 1825/6, it was demolished in 1959. The church was originally owned by Revd Downes from All Saints, who charged the congregation for attending the services. Admission was 6d (2½p), but servants only paid 3d. When John Craig leased it, he abolished the fees. Not satisfied with only leasing the building, he insisted on having ownership of the premises. A long, drawn-out court case followed, which resulted in him losing his claim in 1874.

Christ Church.

The order of the day was simplicity: only simple services and no vicar was allowed to preach wearing a surplice. Consequently, pre-sermon hymns had to be long enough to enable the vicar to remove it. There was no graveyard and the building was later renamed as Christ Church until the bishop declined to fund the necessary restoration work. Its demolition commenced on a foggy day in 1959 as if it were ashamed. The contractors had to borrow a ladder to reach the belfry because their one was too short.

Church Missionary Society
In 1901, there was great excitement when reports circulated about the Church Missionary Society having received a donation of £10,000 (approximately £782,000 today). Sadly, it turned out to be a hoax.

Gurdwara Sahib
This Sikh temple is an amalgamation of *sangat* (friends) from Leamington, Warwick, Kenilworth, and surrounding villages. Its followers once met in different properties at various locations. The building work started in 2008 and finished the following year. It is the third largest *gurdwara* in the United Kingdom and encourages visits from all faiths.

Holy Trinity
Originally known as Trinity Chapel, it later became a church. This started as a breakaway group from Christ Church, sited in Beauchamp Terrace, now known as Beauchamp Avenue. The split was caused by worshippers who resented paying to attend services.

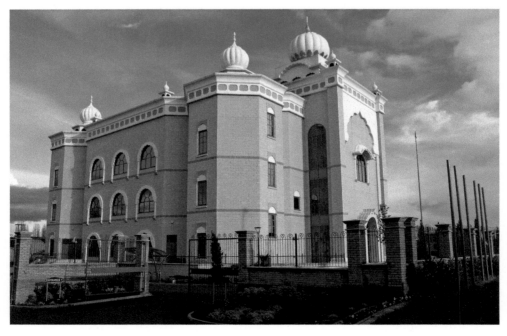

Gurdwara Sahib. (Courtesy of Rwendland)

St Albans.

St Albans (aka St Michael's and All Angels)
John Craig built this church in 1861. It began life as a corrugated iron chapel also known as the New Opposition Church or the Vicar's New Shop in Priory Terrace. He sold it in 1864, and the church was resited in Warwick Street at the junction with Portland Street. The site was in the Orleans House Garden, home of the Working Men's Conservative Club. In 1871, Craig repurchased it and the tower was erected in 1887 to mark Queen Victoria's golden jubilee, which he never saw. By the 1930s it had become an Anglo-Catholic church with visitors from outside Leamington. It was demolished in 1968, and new offices were created in what is now St Alban's House.

St Mary's
As Leamington grew, so did All Saints parish and the church could not accommodate its worshippers. The answer was to build another church, despite Craig's objections, but the new church opened in 1839. Technically, however, it was only a chapel as it had no burial rights. After Craig's death, it was upgraded to a church. Today there remains a corrugated iron building in the grounds, which was typical of the quick-build tin chapels of the nineteenth century.

St Paul's
By 1874, St Mary's parish was too big for its church, and St Paul's was built in Leicester Street to accommodate them and others. Some of Leamington's worst slums were situated behind it.

St Mary's Church.

St Peter's

There were no premises where Roman Catholics could worship until 1822, when the Apollo Rooms in Clemens Street behind Copps Hotel were made available. They moved to George Street in 1828 with space for 300 worshippers. Napoleon III worshipped here and used a tunnel linking it with next door so he could leave quietly and dine with the priests. Larger premises were still needed, and they finally moved to St Peter's in Dormer Place. A new church was built, with bells added in 1878.

The church was severely damaged in 1883 by a candle that had been left in the organ loft. The fire brigade jets were unable to reach it and onlookers declined to help with the pumping. The damage cost £6,000–£8,000 (£480,000–£641,500 today), with Protestants and Roman Catholics contributing towards its rebuilding. In the aftermath of the fire the school in Augusta Place was temporarily used for worship. St Peter's small pineapple spire was removed in 1950.

Early Roman Catholic Church.

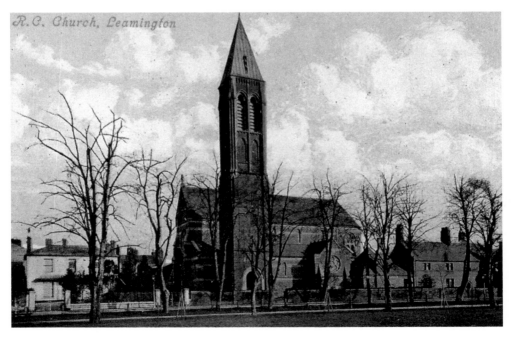

St Peter's.

Spencer Street Chapel

Congregationalists opened this chapel in 1836, providing room for worshippers, burials and popular Sunday schools. Despite these facilities, its opening was oversubscribed, and 100 people were turned away. The Leamington Pleasant Sunday Afternoon Movement met here in June 1901 for their half-yearly book distribution by Mr M. H. Lakin. As the congregations dwindled in the 1980s various other uses were suggested, including a theatre, which did not happen. Future plans include turning the building into a hub for digital and creative activities.

The school facilities were appalling. Schoolboys were educated among tombs and entry into the building was via outside steps. The only natural light was provided by two windows just 18 inches above the ground, which meant the inside was permanently in semi-darkness, lit by candles, lamps and a tiny fire grate.

Spencer Street Chapel and School.

7. Education

This was a continual case of financial constraints versus education. The first recorded educational establishment was Revd Trotman's Sunday school in 1813. Others followed with varying degrees of success. As the town grew, more schools appeared of varying duration. Schools for the poor were tolerated, but only just. These are a selection.

Bath Place School
Recorded as the first school for working-class children, it was set up by Revd Trotman in 1822 and cost parents between 2*d* and 4*d* per week for their children's education. The premises opened in Kenilworth Street before moving to Bath Place in 1859, despite opposition from John Craig. His opposition was at odds with his belief in education for the poor. Such vindictiveness soon caused financial problems, which took nine years to resolve. During the Second World War schooling was shared between the regular pupils and evacuees, and often worked in a shift system. The school closed in 1973 and has been adapted for assisted-living purposes, albeit incorporating some of the building's original features.

Clarendon Street Baptist Chapel School
Opened in 1857, it was temporarily for girls and infants, and was primarily run by Revd Salter and his two daughters. They were assisted by another teacher and a thirteen-year-old pupil teacher.

Eton Villa School
Another school operated by a clergyman – Revd E. Rundell in 1901.

Greyfriars Preparatory School
Nothing to do with the school where Billy Bunter attended, Revd A. Beaver MA ran this establishment at No. 16 Warwick Place in 1901.

Leamington College
Originally situated in Eastnor Grove, it specialised in catering for the sons of nobility and clergy. It was a minor public school in the nineteenth century, once known as Leamington Proprietary College. Their building in Binswood Avenue had a varied existence before becoming the venue for the college. It was purchased in 1903 by the French religious order the Convent of the Sacred Heart and used for training young French Roman Catholic girls. During the First World War, the order returned to France. The next occupants came from Dover College, who stayed for the remainder of the war. On their return to Dover after the war, several Leamington boys went with them. Warwickshire County Council

took it over in 1920 to replace the old college situated in Avenue Road. The building closed as a grammar school in 1979, becoming a sixth-form college before being sold for luxury apartments. Old boys include Frank Whittle and Bernard Spilsbury (see pages 79, 83).

Leamington High School (aka Kingsley School)

Among this school's pupils was Victoria Eleanor Louise Doorly (1880–1950), who obtained an MA in History, which was unusual for women. Born in Jamaica, she lived and was educated in Leamington. She became head of Warwick King's High School for Girls and changed it dramatically by introducing class councils and parent-teacher associations. As a head teacher, she let her girls help with the war effort. Another of her beliefs was that women could be wives, mothers, and careerists. She also wrote novels and was awarded the Carnegie Medal for her study of Marie Curie.

Old Library and Technical School

The Old Library and Technical School was opened in Avenue Road in 1902 at Perkins Garden adjoining the Manor House. Its upper floors housed Leamington Girls' College and later became part of Mid-Warwickshire College Painting and Decorating School. Since closing it has been converted in luxury apartments.

St Mary's School

The prime object of this establishment was for the benefit of children who came from the poorest areas of town, where measles, cholera and other diseases were rampant. Unsurprisingly, complaints were made about the noise, regardless of who caused it. These were coupled with demands the playground be closed. A small child from here was

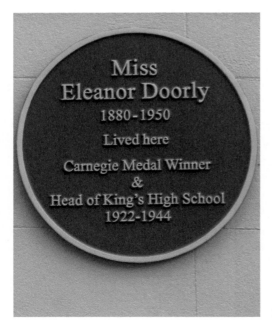

Eleanor Doorly blue plaque.

locked up for scrumping. A lack of money meant a shortage of books and using gas was forbidden in school hours. There was a noted absence of children at certain times of the year, such as Warwick Mop and harvesting, which were counter attractions. Headmaster Henry Stroud avoided caning where possible, but did so for misbehaviour in church.

St Peter's School

The first Catholic school for boys opened in 1848 in New Street, although it was not successful. A later one in Augusta Place, originally a convent for the Sisters of St Paul, was more so.

Southlands School

Southlands was another private school. It was created at No. 85 Radford Road by Jane Elizabeth Tolson in 1933 with five pupils. From 1939 it was run by Mr Grove, known as Goofy, assisted by his wife and some teachers. Pupils wore a purple uniform with a silver letter 'S' embroidered on the blazer pocket, and a school cap. It was a late Victorian building that had been adapted for use as a school. For example, the two most junior classes were held in the same room. The house and outbuildings were demolished later and converted into private housing but kept the name. The author remembers the food being most unappetising, although to be fair this was in the immediate post-war years, with items still rationed. Saving stamps were sold on a weekly basis.

Southlands School.

Southlands School interior.

Ration book.

Savings stamps,
c. 1949.

DID YOU KNOW?
Taking children away from school without a good reason could be costly. On 10 June 1901, Henry Bolt was fined 2s 6d for doing so.

8. Social Issues

Leamington was promoted as a showcase for people to visit for their health and while that might have been true, it was only one side of the town. Looking after the health of the wealthy came at a cost to those who were not so fortunate. There was a dark, hidden side to the town; something that if possible was never to be seen or mentioned.

By 1840, approximately 2,500 people were employed as domestic servants, with four women to every man. Having a basic education did not automatically remove people from poverty as labour was plentiful but pay was low. Employers often demanded proof their employees were regular church attendees.

People were more interested in making money than worrying about the less fortunate. It was a case of 'out of sight, out of mind'. In 1847, the Board of Guardians of the Warwick Union reported on this appalling state of affairs, which had been a health risk for a long time. Apart from the initial shock, nothing changed until cholera appeared in August 1849, and even then nothing really happened. Local officials were worried about the effect this report would have on visitors, so they hid the details and denied any suggestion of the disease being present. Life continued as normal without any improvements. All that mattered was the continual stream of visitors to the town and the money they brought with them.

Raw, untreated sewage was flushed into the Leam, which caused problems downstream. This was the same water used for drinking purposes. Although a system bringing water in from the Newbold Hills was classed as being unfit to drink, still nothing was done to improve matters. It was 1879 before the town had a proper freshwater system, thanks to Alderman Henry Bright. Meanwhile fresh water could be purchased at 1s 2d a pail.

Doctor John Hitchman was a medical practitioner who treated the poor. He operated a hydropathic service and also beautified much of the town. His memorial fountain is in the Jephson Gardens, close to Parade. It is on the site once occupied by Strawberry Cottage. Pine trees were planted around it, which was fine while they were small but not once they were higher than the fountain. Then the needles shed and caused waterflow problems.

Being bitten by mad dogs and contracting rabies was a real fear in the past. Enter Thomas Dilkes, also known as 'Dilkes the Dipper'. He allegedly cured people who were – or thought they were – infected with rabies. Quite simply, he immersed them in a ditch containing spa water. His patients were poor Leamingtonians who queued up in gowns and slippers in the open air awaiting their turn to be dipped. He had a reputation for being successful, so was this the case or were his patients not rabid?

The Warneford Hospital was named after Dr Samuel Wilson Warneford from Bourton-on-the-Hill, Gloucestershire, where he was rector. Having married into money, he spent it lavishly helping other less-fortunate individuals and needy causes. Among

them was contributing 75 per cent of the cost of creating the Warwick, Leamington, and South Warwickshire Hospital, more commonly known as the Warneford. It opened circa 1832–34, providing free medical assistance to the poor. Samuel left £10,000 to the Warneford when he died. This hospital has gone and numerous houses now occupy its site.

Although it concentrated on hydrotherapy, X-rays were pioneered here in 1896. In 1911, it had one horse-drawn ambulance and was the only hospital in the area dealing with emergencies. It remained so until the early part of the Second World War, when Warwick Hospital was improved and dealt with accidents and emergencies, as well as wounded service personnel. During and after the First World War it was the only venue outside Birmingham available for the treatment of venereal disease. Unauthorised practitioners faced a fine of up to £100. Annie Cay, widow of a Birmingham businessman, funded the new maternity block in 1939 that bore her name. Countless Leamingtonians were born here.

Many health problems are associated with poor-quality housing, and early Leamington was no exception. Working residents were poorly paid and lived in cramped accommodation. Those who were domestic servants were only engaged, for financial reasons, by their employers for fifty-one weeks a year. Thus, not being residents for more than a year, they were unable to claim parish relief. The advent of the Agricultural Revolution drove thousands of farmworkers from the land into the towns seeking employment, where living conditions were atrocious.

Class distinctions ruled, and upper-class Leamington chose not to acknowledge the other side of town. For instance, in 1847 a report referred to a court in Regent Street, just

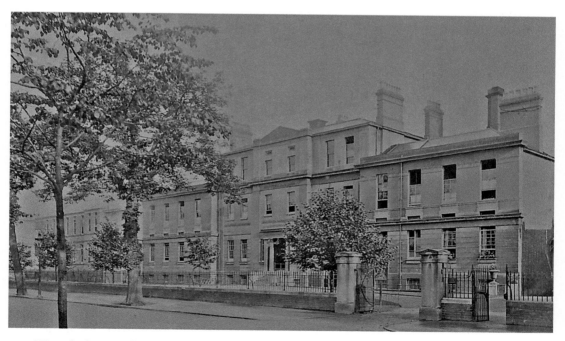

Warneford Hospital.

off Parade, which contained twenty houses built in the smallest possible space, and each one consisted of two 8-foot square rooms and one sleeping area. Ninety-seven people lived in this court, where nine people might reside in a house. A large cesspit in the centre of the yard regularly overflowed and pumps failed. There were nineteen slaughterhouses in the Warwick and Regent streets area with approximately 800 pigsties attached to houses. Brick kilns were sited in Regent Street as early as 1814.

Provided poor-quality houses were out of sight, they were out of mind, thus there was no problem. Another report dated 1850 recorded Guy Street as having eighteen undrained privies. Ranelagh Terrace Infants' School basement held 9 inches of contaminated water. Imperfect privies, open cesspits and drainage problems caused diarrhoea and other gastric diseases. Cholera was blamed on smells and not on contaminated water. Stomach problems were thought to be normal. It would be 1854 before cholera's cause was found to be linked to water. Health risks abounded in poor-quality new properties specially built for workers. Leamington was not alone in having such faults and problems.

In 1851, the country's General Board of Health Report criticised the policy of allowing privy buckets to be emptied into the streets and called for proper sewage disposal and clean water supplies. Leamington ignored the report for twenty-plus years. An example in 1860 highlighted how eighty-five people lived in sixteen houses, complete with open and unfenced cesspits – and this was only one example. Paved areas for the poor were considered an unnecessary expense.

Sub-standard housing did not apply to wealthier people who could afford to have better-quality buildings. These were built to an individual design or chosen from a builder's pattern book, subject to local controls. Overcrowding became a problem during the Second World War with an influx of foreign troops and refugees. This led to the conversion of larger houses into flats. Modern student multi-occupancy accommodation also brings problems.

The first council houses, as they were called then, began in 1923 and were followed three years later with slum-clearance plans. With a trend towards a cleaner style of living, clean clothes became important. For those who did not do their own washing, or use the laundry, there was an alternative – the bagwash. Often described as being the forerunner of laundrettes, people put their dirty clothes in a canvas bag which was collected. After being washed, the contents were returned to them to dry and iron. The author can remember seeing this happening in the 1940–50s.

On a more positive note, in 1901 the Seats Committee were to be asked to provide seats in the Old Warwick Road, described as 'one of the most beautiful & picturesque in the neighbourhood of Leamington'.

9. Fire and Police

Firefighting

As Leamington grew there was no proper fire brigade, only volunteers or insurance company employees. By 1826, the town had only three manual pumps and the entire system was 'grossly inefficient', with nobody taking any responsibility for it. The Euston Place fire should have been a wake-up call, but apparently it was not. (Euston Palace had been built in 1834 and burnt down in 1839.) Ironically, the Birmingham Fire Office statue from the other side of Parade is now housed here.

Early firemen were exempt from being pressed into naval service. Although press gangs operated miles away from the coast, there is no record of them coming to Leamington.

Nearly twenty years later the first real fire brigade was formed, but it was nothing more than a name until 1863. It remained grossly inefficient, as demonstrated by the fire in St Peter's Church. They rejected assistance from other brigades on grounds of cost. By 1881, if a police constable discovered a fire, his instructions were simple: he must raise the alarm by blowing his whistle and shouting 'fire', then run to the police station 'without stopping for one moment'.

When the police took over the fire brigade in 1901 an electric alarm was to be installed in every fireman's house and on the streets, 'providing the cost was not too dear'. By 1905, it was the practice to check the alarms daily at 8 a.m. In the early days the fire appliance was drawn by horses, which had to be 'borrowed' from wherever they could be found.

Fire mark.

Finally, it was accepted this was grossly inefficient and the brigade had its own horse, which could be employed when not in use by the town council.

Early firefighters wore brass helmets, which gave good protection until electricity appeared. The live wires caused serious danger if they connected with the helmets, which were replaced by leather ones.

In 1903, Charles Crowden created a motorised fire tender, which he supplied to Leamington, but it bore no resemblance to modern fire appliances.

When the Stratford Theatre caught fire in 1926, help came from everywhere. Interestingly, the Warwick horse-drawn appliance was only passed by the Leamington motorised one, on the outskirts of Stratford.

Slowly, fires and their risks were being taken more seriously, as Revd Alfred Holden discovered to his cost. He was fined 4s 6d for allowing his chimney to catch fire.

Before the advent of the telephone system in 1937, summoning their services could take time. It was not too difficult in a town, but in more remote places someone had to go to a post office and summon them to the fire by telegram. Staff had to be gathered before leaving to fight the fire. The installation of the 999 system improved everything. Alternatively, you dialled 'o' or waited for the telephone exchange to answer, which took time. Police countrywide had opposed having telephones in stations on the feeble excuse they did not want to cause embarrassment to people asking for help. The telephone number 999 was settled on because the wires carrying the lower numbers, such as 112, could be affected by windy conditions.

Theatre fire at Stratford-upon-Avon, 1926.

With the probability of approaching war, in 1938, the Air Raid Precaution officers and Auxiliary fire services were formed. They were disbanded in the latter stages of the war. Leamington Borough Police and Fire Service had lost their independence by 1947. It was suggested in 1939 to share the water supply in the Old Warwick Road with Warwick Fire Brigade. A sensible idea, one would have thought; but no, such action needed government approval. The fire engine was kept behind the police station in High Street.

Policing

Prior to the establishment of a proper police force, Leamington was policed by a mixture of old-style constables assisted by a court leet and the Association for the Prosecution of Felons.

Towns and communities once had a court leet, and Leamington was no exception. The term 'court' means a place for hearing cases, and 'leet' is really just another word for local. These organisations were an extension of the old manor courts, adopting the roles of law enforcers. Like Leamington, most lapsed when courts as we know them today came into being. From time to time they were revived, but today there are less than fifty courts in the whole country. Leamington's court was revived in 1828 with a headborough or beadle empowered to inflict punishment on wrongdoers. Beadles had the power to whip rogues and vagabonds and remove sturdy beggars from the town. One duty involved the Leamington beadle taking children from the national schoolhouse to church and ensuring their good behaviour. If any misbehaved, he used his staff to hit them on the head. The result was described as sounding like 'cracking nuts'.

Associations for the Prosecution of Felons were popular in areas with no police force, and sometimes when there were. They were an association of local citizens who covered the costs of rewards and prosecutions on behalf of their members and prosecuted offenders. This particular association of local businessmen was formed in 1833 and still meets annually. Its last prosecution was in 1971, which was against a man for fishing illegally in the Leam at Offchurch. He was fined £8.

On 8 December 1824, four watchmen were appointed to patrol the streets. It was later agreed, in 1840, that Leamington would be policed by the newly formed Knightlow Hundred Police, part of Warwickshire. It was a great idea in theory, but not in practice. The number crunchers decided, in all of their wisdom, that Leamington could be policed by seven-eighths of a constable! Such a proposal was completely unacceptable, and Leamington retained its own Borough Police Force until 1947. The failure of this amalgamation caused so much ill-feeling between the two forces that both chief constables declined to speak or communicate with each other. It got to the stage where one of them would cross the road to avoid having to acknowledge the other.

An incident in 1844 would not have helped their relationship. On Monday 21 October, Stoneleigh Abbey (not in Leamington) was invaded and occupied by rival claimants to the estate. Later that day a posse of six police officers from Leamington and twenty-two special constables, accompanied by a large crowd of spectators, marched to Stoneleigh. Much to the disappointment of the spectators, they regained possession of the abbey without any trouble. The invaders were escorted back to Leamington for a later trial.

Left: Leamington borough policeman.

Below: Stoneleigh Abbey.

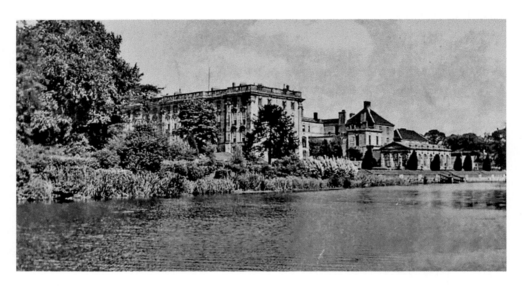

 This was an era when chief constables were appointed from either the army or navy, usually without any policing experience, and they ran their forces accordingly – often quite harshly by today's standards. Likewise, it was a completely new occupation for the first recruits in the more junior positions. The chief constable set the rules, uniform, and standards of behaviour based on his previous career. Although the following incidents relate to Leamington, it was a similar story with police forces elsewhere.

 While constables were issued with a whistle to summon assistance, they were instructed only to use it as a last resort because 'it creates the inconvenience, which it is intended to prevent, by assembling a crowd'. Until 1902 duty armbands were worn on uniforms to indicate the officer was on duty. White helmets and summer-weight uniforms were also available but could only be worn when authorised.

In 1881, the chief constable issued new rules, clearly aimed to bring his men more into line: 'He is at all times to appear neat in his person correctly dressed in the established uniform when on duty, unless otherwise ordered.' Shop blinds had to be high enough for a policeman to walk underneath without having his helmet knocked off his head. There was an exception made once, however, because the officer was so tall.

Another specific order required of them was 'while on duty, he must not enter into conversation with anyone except on matters relative to his duty'. There was a further instruction requiring this order to be 'more thoroughly enforced'.

As late as 1899 policemen could still give people an early morning call, provided it did not interfere with their duties.

There were special instructions for officers giving evidence in court. If obscene language had been used in the incident, they were forbidden to say the actual words. Instead, they wrote them down for the magistrates if they wanted to know. One wonders just what these court sessions were like. An instruction was issued to all officers there to prevent members of the public rushing to leave at the end of the day's business as magistrates had to leave first. In 1904, officers were detailed to stop people spitting on the floor when the court was in session.

Before personal radios evolved, police officers had to be at certain places or points at a particular time. Leamington also had police telephone pillars showing an orange light when a policeman was needed to answer it. The author recalls seeing a policeman walking down Parade with such a light flashing behind him. He told the policeman about it. The officer did not turn round but merely said he could not see any flashing light and walked on. Nowhere else in Warwickshire had this system.

In the 1970s, Leamington police station had an old-fashioned telephone switchboard, which needed an operator to answer it. When someone in the station wanted a number,

Leamington borough police officers. (Courtesy of Warwickshire Constabulary History Society)

Police telephone
pillar. (Courtesy of
Terry Gardener)

a disk would drop down by the extension number on the board. One chief superintendent
was so unpopular that someone drew a pig's face on his disk for all to see when it
dropped down.

Although Leamington police were not mechanised until the 1930s, night duty officers
were instructed to record details of all moving vehicles seen at night.

DID YOU KNOW?
In 1903, there was a gas stove in the police recreation room that was only to be used
for making coffee. They were instructed: 'On no account must it be used for boiling
water for cleaning purposes.'

10. People

Inventors

Sir Frank Whittle and his family moved here in 1916. His father, Moses, took on small premises behind All Saints Church. Frank went to Leamington College and was not keen on sport, but later found he was a proficient sprinter. On leaving school Frank joined the RAF. It is here that he invented the jet engine, which helped destroy the V-1 rockets during the Second World War, despite initial Air Ministry disinterest. He was created Commander of the Order of the British Empire and later Commander of the Order of the Bath and Order of Merit. After his death his ashes were interred at RAF Cranwell. A pub in the Tachbrook Road was once named the Jet & Whittle after him.

Ben Bowden designed an energy-storing bicycle called the Classic. It stored energy while travelling downhill and released it when going up. He maintained it could move at a speed of 5 mph when going up some gradients. The problem was cycle manufacturers were unwilling to create new tools to make it, so the Classic never took off. Although a few were made in America they remained too expensive and now are much-wanted collector's item.

Literature

Sir John Betjeman composed a poem titled 'Death in Leamington Spa'. This moving verse is about a nurse who discovered her patient had died alone, in a room overlooking Leamington. It first appeared in 1932, long before he became Poet Laureate.

Sir Frank Whittle.

The little-known children's author Gilbert Dalton lived here from 1945 to 1958. Formerly a journalist for the *Coventry Evening Telegraph* and being unfit for military service, he began writing children's novels and stories for the popular boys' comics of the day, such as *Adventure, Hotspur, Rover,* and *Wizard.* Unlike today, these stories consisted of very few pictures and were mostly written words. Gilbert was a prolific writer who often managed 1,000,000 words a year. His best-known characters in these comics were the Tough of the Track, Wilson the Wonder Athlete, and Braddock. These were all fantasy characters aimed at middle-class readers. Two of his novels, *The Spider's Web* and *Catch that Spider,* have local connections and were first heard on *Children's Hour.* They concern the activities of a nineteenth-century highwayman who had a silver spider's web sewn onto his mask and operated in Warwickshire.

Charles Dickens used Holly Walk as the setting for the meeting between Edith Granger and Mr Carker in *Dombey and Son.* He stayed at the Royal Hotel in 1838.

American novelist Nathaniel Hawthorne lived at No. 10 Lansdowne Circus for a while in the 1850s, which he called 'his little nest'. Nathaniel's best-known novel is *The Scarlet Letter,* which is set in Massachusetts between 1642 and 1649. It concerns the trials and tribulations of a married woman who committed adultery and has to wear a red 'A' for the rest of her life as a sign of her shame. All the houses in Lansdowne Circus were built between 1836 and 1840 and are all Grade II listed. The garden at the front is strictly for the residents' use. Celia Imrie stayed here in 2015.

Clarendon Square was the location for a non-Conan Doyle Sherlock Holmes story.

Military
Squadron Leader Henry Maudslay DFC was born in 1921 at Lillington and educated at Eton. He joined the RAF and was described as 'a modest & unassuming individual'. Enjoying a successful RAF career, he was selected to join 617 Squadron under Wing Commander Guy Gibson DSO DFC. Barely twenty-one-years old, he was the youngest pilot in *Operation Chastise,* which was the raid on the Möhne, Eder and Sorpe dams in the Ruhr on 16/17 March 1943. Henry was killed attacking the Eder Dam.

Politicians
Robert Anthony Eden was elected Conservative Member of Parliament for Leamington and Warwick in 1923. His Labour opponent was Darling Daisy, Countess of Warwick, who was his sister's mother-in-law. Despite her aristocratic background, she had been persuaded to stand for Parliament. Her connection to Eden was coincidental. He was prime minister from 1955 to 1957.

Royalty
Although she had been to the town as a princess, Queen Victoria visited again with Prince Albert in 1847. It was a hot day and her railway carriage had blocks of ice in it and a wet felt roof added to combat the high temperatures. On other occasions when passing through, she would stop for refreshments and use the station facilities or just the platform. She disliked taking any refreshments on her train while it was in motion. These stoppages caused delays to other services.

Although not royalty, Henry Peach Robinson arrived in Leamington during 1853 and worked for bookseller Joseph Glover, who also ran the *Courier*. Already a gifted artist and sculptor, Peach opened his first photographic studio in Upper Parade. Prince Albert became one of his patrons and the premises expanded, but then poor health made him retire to London. When his health improved he moved to Tunbridge Wells, Kent, where he died at the age of seventy.

Following Queen Victoria's death in 1901, the mayor set the trend for future such occasions by reading the proclamation of Edward VII, now king, from the town hall. Once her death was announced, the town went into public mourning, with muffled church bells and drawn blinds. Rees Bros of Nos 96–98 Warwick Street advertised themselves as being 'the best shop to acquire black material'.

A group of young men who wanted to witness Queen Victoria's funeral walked to Rugby railway station, where they caught a train to London. There were no closer railway stations operating for them to use. Albert Toft later created the former queen's statue, which was moved by bomb blasts in 1940.

In 1901, a special showing of *Aladdin* was held at the Theatre Royal in honour of Edward VII becoming the new king. Its performance included patriotic songs, comedians, pretty girls, superb dresses, and magnificent scenery.

Lady Diana, Princess of Wales, visited Leamington and Warwick in 1986. Her approach into the town from Baginton was marred by black refuse bags in the road, which were waiting to be collected.

Henry Peach Robinson.

King George V proclamation.

Queen Victoria's
funeral, London.

Visit from Lady
Diana, 1986.

Scientists

Sir Bernard Spilsbury (1877–1947) was born here and educated at Leamington College
before going to Magdalen College, Oxford. During the early twentieth century he became
the country's leading forensic pathologist. His evidence convicted people such as Hawley
Harvey Crippen, Herbert Rouse Armstrong, and George Joseph Smith. As his career
progressed, he believed he was infallible. Today, with the advance in forensic science,
doubt has been cast on some of his testimonies, which are possible miscarriages of
justice. He worked alone and never trained any students. In 1947, while suffering from
depression and other worries, he died by suicide through using coal gas.

Sir Bernard Spilsbury.

11. War

It can be argued that the French Revolutionary Wars and later the Napoleonic Wars helped Leamington's expansion. England had been at war with France between 1792 and 1815, leading to a growth in staycations, to use a modern word. Leamington was part of this growth and played its own part as various events unfurled.

Crimean War

Despite the objections to children being in the Jephson Gardens, in 1856 there was a mile-long procession to mark the end of the Crimean War, which finished here. Children took part wearing straw hats or bonnets, with fireworks and food when they reached the gardens.

South African War

When Ladysmith was relieved on 28 February 1900, it was a cause for country-wide celebrations. The Boers had besieged the city since early November and continued doing so during the infamous Black Week of 10–17 December 1899, when the British suffered a string of defeats. Now there was good news to be celebrated, with open-air dancing under the bridges. Dancing has always been a popular entertainment in one form or another. There was more dancing under the bridges to celebrate the Relief of Mafeking a few weeks later. Returning troops disembarked at Milverton railway station and marched to Warwick on foot, much to the impatience of other road users.

First World War

Once war was declared there was a flurry of activity, inflamed by patriotism, and while conscription had not yet arrived, thousands of young men and boys enlisted. Billeting of troops followed and, generally speaking, was a popular move that brought in extra cash to the families and resulted in long-lasting friendships. Not every dwelling was suitable, however, and licensed premises were only to be used as a very last resort. In 1915, Warwick residents complained there were more billetings in Leamington than in the county town. The military paid 17s 6d per week for other ranks, which included being fed. Officers paid 3s per night but provided their own food. The Labour Exchange supplied forms for women wishing to be considered for war work.

When Warwick troops were transported to their destinations by train from Milverton station they were often brought there by private transport. Horses were in great demand and local farriers raised the price of shoeing. The army had a need for farriers and recruited them wherever they could. They increased the maximum age to forty-five and added an extra 5s a day in wages and separation allowance. There was also a nationwide census for horses to be impressed into military service.

Following a nationwide appeal, the vicar of All Saints pleaded for socks for troops. His plea was well received as he was inundated with them. There was at least one report of a white feather being issued to a young man who had not enlisted into the army.

The Incomparable 29th Division

Prior to embarking for Gallipoli, the 29th Division spent time in Oxfordshire and Warwickshire, with men being billeted in Leamington. Here and elsewhere they were made very welcome by the locals. The division was comprised of soldiers who had been abroad at the outbreak of war but were now recalled. This new 29th Division was formed between December 1914 and March 1915. When they moved out there were emotional farewells and later sadness when the casualty notices appeared. There had been one wedding here at All Saints. When a group marched to Leamington from Banbury they were escorted all the way by children who had known them. By the time they had arrived it was too late for the children to walk home, so they were accommodated in Warwick Workhouse overnight. The next day the soldiers paid for their return home by train.

When troops arrived they were led to their billets by the police, assisted by Boy Scouts. Not everyone approved of the billeting system, with the Bishop of Worcester concerned about immorality occurring. The Manor House Hotel became their new divisional headquarters. Although it was a closely kept secret about their immediate posting, the general belief was that it would be France. An enterprising young lady gave French lessons

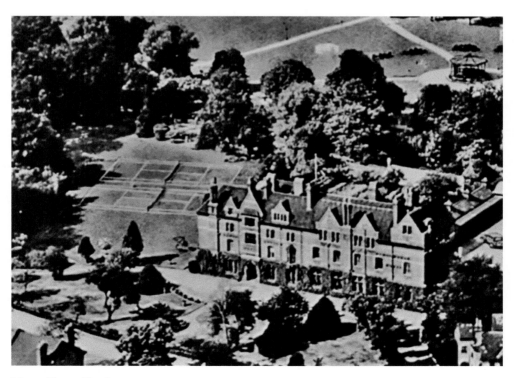

Manor House Hotel.

for the troops. This was not grammatical French, but practical. Going out to Gallipoli was not what they expected. For the survivors, France was the campaign area after leaving the Dardanelles, where these lessons may have proven useful.

Soldiers who had previously been in the tropics found the winter weather hard and several were admitted to the Warneford. Not all went well, and there were problems, sometimes involving alcohol. There was a strong abstinence feeling in Parliament, which did not help matters.

On 12 March 1915, George V appeared on the London Road (A45) at Stretton-on-Dunsmore and inspected the entire division, which took over an hour to pass him. It was an impressive sight, and soon afterwards the 'Incomparable 29th Division' moved out of the area and on to Gallipoli. Here their horrific losses caused much sorrow throughout this part of the Midlands. From there they went to France, still making a name for themselves. By the end of the war they had suffered 94,000 casualties and won twenty-seven Victoria Crosses. Their memorial stands at the junction of the A45 London Road and the Fosse Way. In his tourist-guiding capacity, the author once took a coachload of Irish visitors along the A45 and mentioned the Royal Dublin Fusiliers as being part of the division. At their next stop, one of the passengers approached and thanked him because his grandfather had served in that regiment, and it helped his family history research just a little.

Peace

The Treaty of Versailles was signed on 28 June 1919 and effectively ended the war. Three weeks later there were celebrations in Leamington, which included music in the Pump Room Gardens. There was a military march past involving personnel who had served in all branches of the armed services. A maroon was fired at midday, which heralded two minutes' silence. Later there was a Pageant of Peace, which included decorated lorries, cars, carriages, bicycles, motor bicycles perambulators and traders' delivery floats. The entertainment continued during the evening with fireworks and flares.

Albert Toft created the war memorial in 1922.

Second World War

Just over twenty years later and the world was back at war with Germany and its allies. More names would be added to the war memorial.

Fire watching was an important role in wartime, as was the ARP or Air Raid Precautions staff. With typical government parsimony, these volunteers were originally not given any uniform, just an armband to wear. Basic uniform and sub-standard helmets followed. It was a similar situation with their rations, which were minimalistic. In May 1940, Anthony Eden called for volunteers to join the Home Guard. To begin with they had no uniforms or even weapons. Rationing appeared again and stayed on well after the end of the war.

There was another great need for billets, resulting in additional facilities such as the Allied Services Canteen in Bertie Terrace, which was open every night for food and hot drinks. Dunkirk survivors attended a reception for them here and at the golf club.

Lighting regulations. (Courtesy of Terry Gardener)

Although not really a target for air raids, Leamington received some damage to people and property thanks to the Luftwaffe. Coventry was their main target, however, and the resulting fires there were seen from Leamington, followed by the arrival of local and more international refugees. Among them were Poles and Czechs who were billeted in Victoria House. They were well received and some married local girls, settling here after the war.

Once again Milverton railway station was used for military transport, including the Warwickshire Yeomanry who had now become mechanised and returned here.

A list of air-raid victims from this period has been added to the war memorial.

Operation Anthropoid

Members of the Free Czech Army arrived in the district in late 1940, with their headquarters based at Harrington House, where the Spa Centre stands today, and they integrated well into the community. A small group of them returned to Prague in 1942, tasked with assassinating Reinhard Heydrich, nicknamed 'the Hangman', who was a main promoter of the Holocaust. They linked up with the local resistance, who were unhappy about the idea, fearing horrific reprisals, and rightly so.

On 27 May 1942, Jan Kubiš and Jozef Gabčik mortally wounded Heydrich, who died on 4 June. They took refuge in the Cathedral of Saints Cyril and Methodius where they died. The Gestapo executed the bishop and his senior lay personnel in retaliation. More innocent victims were the inhabitants of the villages of Lidice and Ležáky. A memorial rose garden and fountain to their memory were created in the Jephson Gardens. Made

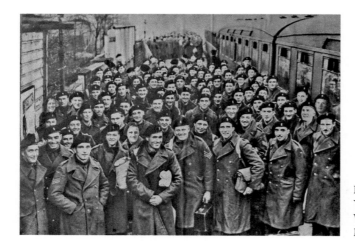

Return of Warwickshire Yeomanry. (Courtesy of The Warwickshire Yeomanry Museum Charitable Trust)

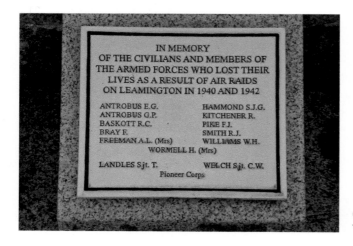

IN MEMORY
OF THE CIVILIANS AND MEMBERS OF
THE ARMED FORCES WHO LOST THEIR
LIVES AS A RESULT OF AIR RAIDS
ON LEAMINGTON IN 1940 AND 1942

ANTROBUS E.G. HAMMOND S.J.G.
ANTROBUS G.P. KITCHENER R.
BASKOTT R.C. · PIKE F.J.
BRAY F. SMITH R.J.
FREEMAN A.L. (Mrs) WILLIAMS W.H.
 WORMELL H. (Mrs)

LANDLES Sjt. T. WELCH Sjt. C.W.
 Pioneer Corps

Czech fountain. (Courtesy of Wilson 44691)

St Cyril and St Methodius Cathedral, Prague, showing war damage.

from Hornton stone by local sculptor John French, the memorial is in the form of a parachute, the strings of which are represented by falling water. The names of those who were dropped into Prague have been inserted in the spaces between the strings of the parachute. Several movies have been made about this story. In one of them the late David Warner played the part of Heydrich.

Air-raid victims. (Courtesy of the Trustees of Warwickshire Yeomanry Museum)

12. Miscellaneous

River Leam

Giving Leamington its name, the Leam rises at Hellidon Hill, Northamptonshire. Being first recorded in AD 956, it was originally known as Limenan or 'elm tree river'. Slightly less than 40 miles long, the Leam does not fare well in the quality of its water. Flowing through the town, the river is prone to flooding.

By 1890, the existing Adelaide Bridge was unsafe for heavy traffic, which was banned from using it but the order was ignored. Borough surveyor William Louis de Normanville had it rebuilt despite opposition from those who did not think it was necessary.

Another bridge crosses the Leam at Willes Road, where abandoned firearms were once found in the river here. Although their origin was never confirmed, it was thought they were wartime excess, dumped here by the police.

The original Victoria Bridge was built of brick and divided the old and new towns. A new stone one was built and ceremoniously opened in 1840. Panic reigned the next day when the commemorative plaque was found to be missing and believed to have been stolen. In fact, it been moved overnight for safety.

Standing here, with one's back to the Colonnade, there is a good view of the suspension bridge created by de Normanville over his concrete weir, on the original site of Oldham's Mill. What is believed by some to be an old drovers' track crosses the Leam here. The bridge is now Grade II listed, and the whole scheme was completed in 1903. Surviving the 1901 floods, the bridge now collects love padlocks. Leaving the suspension bridge and moving towards Leam Terrace is the site where the old Victorian underground public toilets once stood.

Elephants

By the suspension bridge are murals (2022) reminding people of the town's association with elephants. This is known as *Elephant Wash* and is an access to the Leam. It was used for washing horses and carts, but is best remembered for the elephants who supposedly used it. The story goes how they came from Sam Lockhart's Circus, but tended to create quite a noise, which interfered with divine service on Sundays. Sam's elephants were known as Jack and Jenny, and one was reputed to have been buried in the garden of a house at No. 1 Warwick New Road. Sceptics derided the tale until 2015 when elephant bones were found there during the building of a new car park. The best-known elephant statues in town are Trilby, Haddie and Wilhelmina (sometimes called the Three Graces), which can be found in Livery Square. Lockhart was a big friend of Daisy, Countess of Warwick, who kept a small pet elephant at the castle that ate food off her plate. There is doubt today as to how reliable the tale is of the *Elephant Wash*, but the site is there.

Drovers Road.

Suspension bridge padlocks.

Elephants mural.

Elephants statues.

Elephant Wash.

Town Clerk

In 1901, when Leonard Rawlinson was appointed town clerk on a salary of £400 per annum, the council agreed he should wear a gown when in attendance of the mayor. A councillor objected, arguing if the council wanted him to appear bigger they should give him a pair of stilts. 'They wanted grit not gowns.' The motion was carried, with him being the only objector.

Town Hall

Originally sited in High Street, the town hall also housed the police station. When the town hall was moved to Parade the police station remained there until well into the 1960s. The building later became the Polish Centre and has been another location for a *Dalziel and Pascoe* episode.

A new town hall was needed in 1881 because the population was circa 23,000. Denby or Denbigh Villa, adjoining the Regent Hotel, was chosen as the site. The building was once owned by John Williams, founder of the hotel. His wife Sarah's maiden name was Denby. It was not a popular design and was known as the municipal building, until becoming the town hall later. Today it houses the town council, although the premises are maintained by Warwick District Council and is a multi-use building.

Floral Clock

A final reminder of Leamington's past and how time has moved on. A favourite during the Lights of Leamington, the floral clock now no longer exists as such, although its

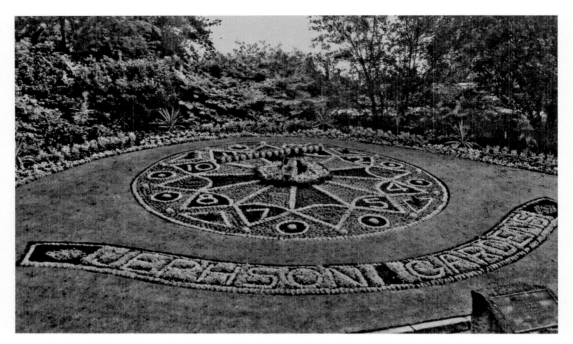

Floral clock.

flower bed site is still maintained. Sadly, it became a regular target for vandals, despite rewards being put up by local businesspeople, and had to be dismantled.

Select Bibliography and Further Reading

Black's 1881 Guide to Warwickshire (Country Books)

Cave, Lyndon F., *Royal Leamington Spa: A History* (Phillimore & Co., 2009)

Drew, John H., MA, FRSA, *The Book of Royal Leamington Spa: The Last Great English Spa* (Barracuda Books Limited, 1978)

Griffin, Alan, *Leamington Lives Remembered: The Stories of Some Notable Residents* (Feldon Books, 2012)

Holland, Chris, *Before Gallipoli* (Warwickshire Great War Publications, 2014)

Jeffs, Michael (for the Leamington History Group), *Royal Leamington Spa: A History in 100 Buildings* (Shay Books, 2018)

Jennings, Allan, Martin Ellis and Tom Lewin, *People, Pubs and Clubs of Royal Leamington Spa*, Books 3 and 4 (Warwick Printing Company, 2017)

Jennings, Allan and Tom Lewin, *Shops of Royal Leamington Spa – Nostalgia, Photos & History* (Warwick Printing Company, 2019)

Long, Jenny and Andrew Barber, *Graciously Pleased Royal Leamington Spa – 150 Years* (Mayneset, 1988)

Manning, J. C., *A Facsimile Reprint of Glimpses of our Local Past* (A. Tomes Ltd, 1991)

O'Shaughnessy, Frances, *A Spa and Its Children* (Warwick Printing Company, 1979)

Sutherland, Graham, *Edward's Warwickshire January – March 1901* (Knowle Villa Books, 2009)

Sutherland, Graham, *Edward's Warwickshire (South) April–June 1901* (Knowle Villa Books, 2011)

Sutherland, Graham, *Leamington Spa: A Photographic History of Your Town* (Black Horse Books, 2001)

Sutherland, Graham, *The Leamington Beat: 1881–1923* (Warwickshire Constabulary History Society)

Sutherland, Graham, *The Warwick Chronicles 1813–1820* (Knowle Villa Books, 2007)

Sutherland, Graham, *Warwick at War* (Pen & Sword, 2020)

Sutherland, Graham, *Warwick in the Great War* (Pen & Sword, 2017)

Sutherland, Graham, *Warwickshire Crimes & Criminals* (Knowle Villa Books, 2008)

The Leamington Literary Society, *A Last Look Back* (Warwick Printing Company, 1983)

The Leamington Literary Society, *More Looking Back* (Warwick Printing Company, 1980)

The Leamington Literacy Society, *The Leamington We Used to Know* (Roundwood Press, 1977)

Warwickshire County Library, *Village into Town* (1980)